IMAGES
of America
PENNSYLVANIA'S BACK MOUNTAIN

On the cover: **THE STEAMBOAT KINGSTON ON HARVEY'S LAKE.** The steamboats *Kingston* and *Wilkes-Barre* were built in 1903 by the Harvey's Lake Steamboat Company, near the Rhoads Hotel landing on Harvey's Lake. The steamboats were identical; each was 70 feet long and 12 feet wide with a 4-foot draft. The *Kingston* was launched at 4:00 p.m. on May 13, 1903. A pier was built for the steamboats on the inlet iron bridge between the Oneonta Hotel and the Hill's pavilion. (Courtesy of the FCP collection and the Luzerne County Historical Society.)

IMAGES
of America

PENNSYLVANIA'S BACK MOUNTAIN

Harrison Wick

Copyright © 2009 by Harrison Wick
ISBN 978-0-7385-6278-0

Published by Arcadia Publishing
Charleston SC, Chicago IL, Portsmouth NH, San Francisco CA

Printed in the United States of America

Library of Congress Catalog Card Number: 2008928789

For all general information contact Arcadia Publishing at:
Telephone 843-853-2070
Fax 843-853-0044
E-mail sales@arcadiapublishing.com
For customer service and orders:
Toll-Free 1-888-313-2665

Visit us on the Internet at www.arcadiapublishing.com

Dedicated to my loving wife, Kimberly.
Her strength and encouragement made this book possible.

Contents

Acknowledgments 6

Introduction 7

1. Kingston Township 9
2. Dallas 51
3. Lehman Township 95
4. Harvey's Lake 103

Bibliography 127

Acknowledgments

The research for *Pennsylvania's Back Mountain* took me all over northeastern Pennsylvania. I want to thank the Back Mountain Historical Association and the Luzerne County Historical Society, Misericordia University, Pennsylvania State University, the Lands at Hillside Farms, the Religious Sisters of Mercy, the Harvey's Lake Yacht Club, the Dallas Rotary Club, and the George M. Dallas Lodge, No. 531, Free and Accepted Masons, for the use of their history and photographs. Special thanks must go to Albert Billings, Donald Britt, Joan Coolbaugh Britt, John N. Conyngham III, William H. Conyngham, Judith Simms Dawe, Jean Dobinick, Wilhelmina Estock, Howard and Lillian Gola, Mark Gregario, Omar Hallsson, Louise Schooley Hazeltine, Stephen B. Killian, Dr. Michael A. MacDowell, Elizabeth Rienzo Noll, Harold D. Owens Jr., F. Charles Petrillo, Pauline Shaver Roth, Roger Samuels, Marie Thomas Sowa, Dani Vaughn-Tucker, Dorothy King Wadas, Frank Wadas, Carol Wall, and William Wentz. Gathering the photographs and conducting research was only part of this project, and I must acknowledge the effort in collecting and organizing oral histories conducted by the history students of Dr. Allan Austin at Misericordia University. I wish to thank the staff of the Mary Kintz Bevevino Library at Misericordia University and the Stapleton Library at Indiana University of Pennsylvania for their support. Lastly, I must acknowledge the many people and organizations that have donated photographs, manuscripts, and collections to historical societies, libraries, archives, and special collections, because without you, projects like this would not be possible.

INTRODUCTION

The Back Mountain is a geographic area in northeastern Pennsylvania that includes Dallas Borough and Dallas Township, Harvey's Lake, Jackson Township, Kingston Township, the villages of Trucksville and Shavertown in Kingston Township, Lake Township, and Lehman Township. The Back Mountain encompasses approximately 110 square miles in Luzerne County behind the Endless Mountains adjacent to the Wyoming Valley. The Back Mountain changed substantially after the 1972 flood caused by Hurricane Agnes devastated many parts of Pennsylvania. The Back Mountain has grown into a suburban community due to its proximity to Wilkes-Barre and Scranton. The Back Mountain remains a beautiful part of Pennsylvania with agriculture, parks, creeks, and recreation. This book includes postcards, photographs, and sketches representing many of the villages, boroughs, and townships in the Back Mountain.

The Back Mountain is unique in Luzerne County. It is one of the few areas in northeastern Pennsylvania without rich deposits of anthracite coal. Early settlements in the Back Mountain developed after the American Revolution. The villages, boroughs, and townships that make up the Back Mountain have a rich history of farming, business, social and civic organizations, churches, higher education, and recreation. Kingston Township is called the gateway to the Back Mountain with the rock cut and the Dallas Memorial Highway connecting the township to the Wyoming Valley. Dallas Township was formed from Kingston Township in 1817, and Dallas Borough was incorporated in 1879. Dallas is the heart of the Back Mountain and is centrally located in the region. In 1829, Lehman became the 10th township in Luzerne County. Idetown in Lehman Township was named for Nehemiah Ide and his family, who first settled in the area in 1799. In 1781, Harvey's Lake was discovered by Benjamin Harvey, who was returning from Fort Niagara where he was held as a prisoner of war by the British. The Borough of Harvey's Lake was created in the 1960s from Lake Township, which was incorporated in 1841.

There are two institutions of higher education in the Back Mountain: Misericordia University in Dallas and Pennsylvania State University Wilkes-Barre in Lehman. The founders of College Misericordia, the Religious Sisters of Mercy, came to Wilkes-Barre in the 1870s and created hospitals and schools in northeastern Pennsylvania. In 1924, College Misericordia was founded in Dallas. It soon prospered as the first four-year college in Luzerne County. College Misericordia grew tremendously after the first five students graduated in 1927. The college achieved university status in 2007 and became Misericordia University. Pennsylvania State University Wilkes-Barre moved to Lehman after the donation of the Hayfield House in 1964. The Hayfield House was built for John N. Conyngham II and his wife, Bertha Robinson Conyngham, who founded Hayfield Farm in 1910 and raised Clydesdale horses. Pennsylvania State University converted the property into administrative offices and classrooms, and the Hayfield House became the center of campus.

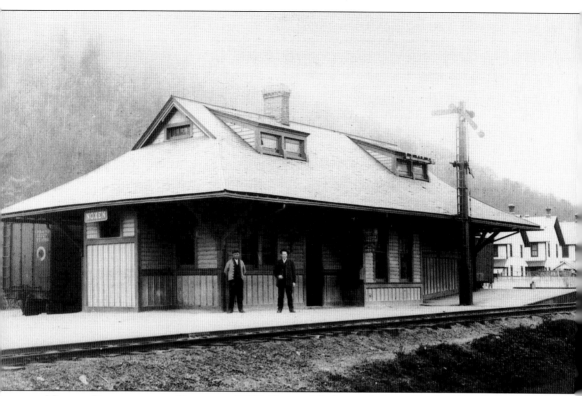

Noxen, Pennsylvania Depot, c. 1900. Pictured (left to right) are Charles Thomas and the stationmaster Harry Harvey. The Bowman's Creek branch of the Lehigh Valley Railroad between Wilkes-Barre and Towanda was 79.2 miles, and it was used as an alternate route to the main line. The Bowman's Creek branch transported ice from Mountain Springs, leather products from the Mosser Tannery in Noxen, dairy and lumber products, passengers, and local freight. The attractions at Harvey's Lake were a major tourist destination for train passengers. The Noxen station was built in 1892–1893, close to the Mosser Tannery. Regular passenger train service from Noxen started in November 1892 and was discontinued in the 1930s. Freight service continued to operate through the 1950s between Luzerne and Noxen servicing the Mosser Tannery. The Lehigh Valley Railroad abandoned the Bowman's Creek branch on December 22, 1963. All other train stations were razed in the Back Mountain, but the Noxen station was preserved by the North Branch Land Trust. Plans are underway to utilize the restored train station as a museum and community center. (Courtesy of Harry Owens Jr. and the FCP collection.)

One
KINGSTON TOWNSHIP

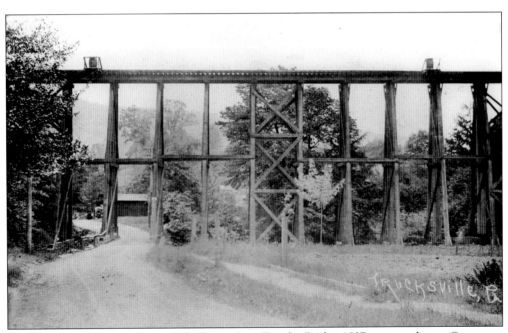

TROUT RUN TRESTLE, 1900S. The Trout Run Trestle, Bridge 183B, spanned over Carverton Road in Trucksville. Grading for the railroad between Luzerne and Dallas began on May 30, 1886. The Bowman's Creek branch of the Lehigh Valley Railroad was completed between Wilkes-Barre and Towanda, and regular passenger train service started in 1893. Behind the trestle were the Kingston and Dallas Turnpike and the trolley station owned by the Wilkes-Barre, Dallas and Harvey's Lake Railway, which was consolidated into the Wilkes-Barre Railway Corporation in 1909. (Courtesy of Louise Schooley Hazeltine.)

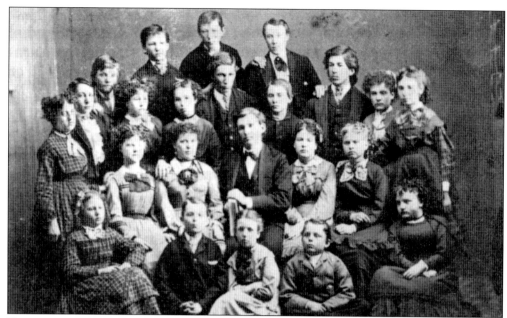

TRUCKSVILLE SCHOOL STUDENTS, 1871. Pictured here are Trucksville School students, including (first row) Nora Smith, Luther Hegaman, Isabelle Beisher, John Hegaman, and Mary Lewis; (second row) Ruth Rice, Clara Patterson, Hamlin E. Cogswell (1852–1922), Kate Beisher, and Josephine Hazeltine; (third and fourth rows) Capitola Baker, William Harter, Crandall Rice, Esther Robbins, Lambert Holcomb, Augusta Hegaman, Jesse Scovill, Alfred Holcomb, Al Harter, Ira Gray, Asa Holcomb, Clara Beisher, and Addie Wall. (Courtesy of Louise Schooley Hazeltine.)

HILLSIDE COTTAGE, 1880S. The two-story Hillside Cottage is shown with the wraparound porch before the addition of the third floor. In 1881, William L. Conyngham (1829–1907) purchased 106 acres in Trucksville from Joseph Harter. This was the foundation for Hillside Farms. This photograph shows William H. Conyngham (1868–1943) driving a team of horses in front of the cottage. Construction of the cottage started in 1882. (Courtesy of the Lands at Hillside Farms.)

WILLIAM H. CONYNGHAM ENTERTAINING FRIENDS AT HILLSIDE FARMS, JULY 1888. In 1889, William H. Conyngham graduated from the Sheffield Scientific School at Yale College. The Conyngham family owned a large Victorian house on South River Street in Wilkes-Barre that was later purchased by Wilkes University, and the property was used for the Dorothy Dickson Darte Center. (Courtesy of the Lands at Hillside Farms.)

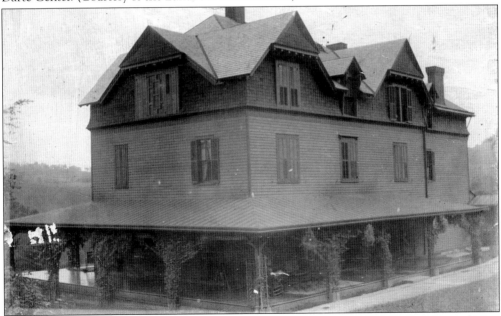

HILLSIDE COTTAGE, SUMMER 1891. Many homes in the Back Mountain were summer residences for families in the Wyoming Valley. The Hillside Cottage was not a year-round residence and was used May through November. This photograph was taken next to the pavilion and shows the three-story Hillside Cottage before the addition of the attic, tower, and enclosed summer porches. (Courtesy of the Lands at Hillside Farms.)

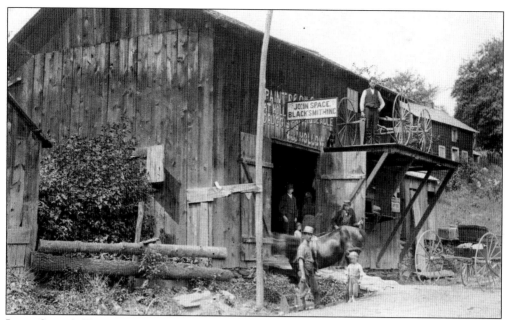

JOHN SPACE'S BLACKSMITH SHOP, 1895. This shop was located on the Kingston and Dallas Turnpike near Carverton Road in Trucksville. John Space made wrought iron fence posts and hardware, shoed horses, repaired wagon wheels, and built wagons and buggies. He sold household supplies, including paint and rope. John Space sold the blacksmith shop to Joseph Bulford, who owned the property until the 1940s. (Courtesy of Louise Schooley Hazeltine.)

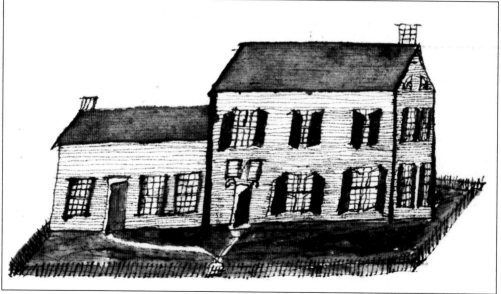

CAROLINE RICE SKETCH OF THE RICE HOUSE, 1840. This house was built by Caroline Rice's parents, Jacob and Sarah Rice, in 1828, on Pioneer Avenue. Jacob Rice (1783–1858) was a mill owner and merchant who came to Trucksville in 1815. He organized the local Methodist congregation. In 1818, Rev. George Peck (1797–1876) started preaching to 12 congregations, including Trucksville and Dallas, over a 136-mile circuit. (Courtesy of Louise Schooley Hazeltine.)

VIEW OF TRUCKSVILLE, C. 1905. This photograph was taken from Sutton Road overlooking the fields and buildings at Hillside Farms and Hillside Road at the bottom of the hill. Trucksville was named for William Trucks, who purchased land along Toby's Creek from Joel Lucas on April 22, 1803. William Trucks built and operated several mills in Trucksville. This photograph shows the Cliffside section of Trucksville. (Courtesy of the Lands at Hillside Farms.)

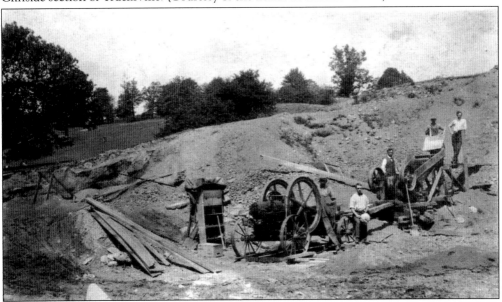

SAND AND GRAVEL QUARRY, C. 1898. The quarry was located near Sutton Road on the farm owned by Wesley David Sutton (1862–1942), pictured in the center. Sutton Road was laid out in 1803 between the Fuller and Baldwin mills bordering property owned by William Trucks. The quarry overlooked Hillside Farms. Hillside Farms purchased the Sutton farm from the estate of Wesley David Sutton in 1946. (Courtesy of Joan Coolbaugh Britt.)

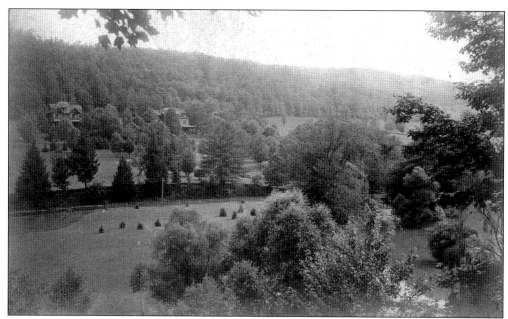

HILLSIDE COTTAGE AND THE COTTAGE ANNEX, 1905. The annex was built to accommodate guests and was connected to the Hillside Cottage by a covered walkway. The annex had a kitchen and dining room on the first floor, the second floor was a ballroom, the third floor was used for guest rooms, and the fourth floor was servants' quarters. (Courtesy of the Lands at Hillside Farms.)

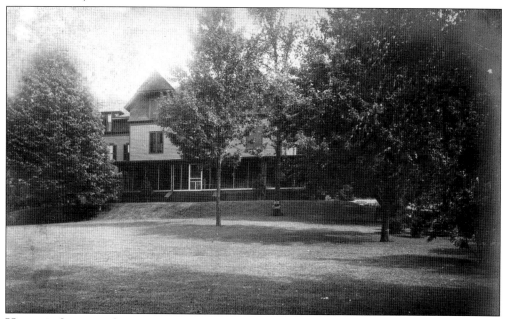

HILLSIDE COTTAGE SEEN FROM THE FRONT LAWN, 1905. The cottage annex would be on the left and was built for entertaining summers guests. This photograph shows the Hillside Cottage wraparound porch after it was screened in. Shortly after this photograph was taken, the Hillside Cottage interior was updated with electricity, lighting, running water, indoor plumbing, and a chain-driven elevator. (Courtesy of the Lands at Hillside Farms.)

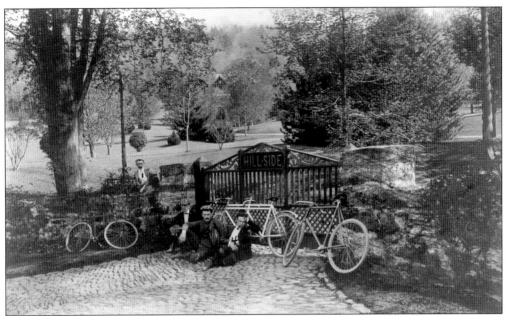

WILKES-BARRE WHEELMEN BICYCLE CLUB, MAY 1899. Club members relax in front of the wrought iron gate leading to the Hillside Cottage. The photograph includes Robert Kaufman (left), club captain Erskine L. Solomon in front of the tandem bicycle leaning against the gate, and Frank Clark (right). This photograph was taken from Hillside Road between the Wilkes-Barre Water Company filter plant and Hillside Farms. (Courtesy of the Lands at Hillside Farms.)

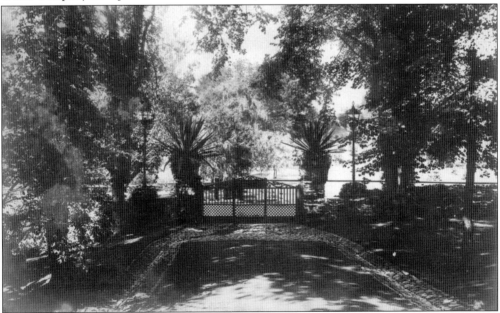

WROUGHT IRON GATE, HILLSIDE COTTAGE, 1920S. This view was taken from the driveway leading to the Hillside Cottage, looking toward Hillside Road across from the park and greenhouses at Hillside Farms. The gate leading to the Hillside Cottage was installed in the 1890s. It was replaced in the 1930s with new sets of gates across from each other on Hillside Road. (Courtesy of the Lands at Hillside Farms.)

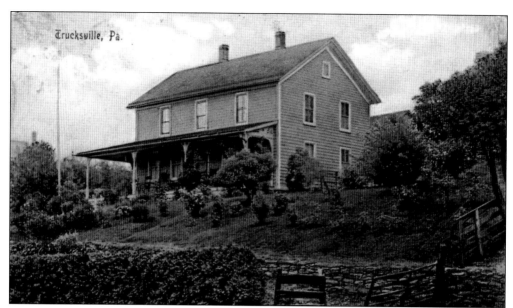

HOUSE OWNED BY A. M. WOOLBERT. A. M. Woolbert owned a house in Trucksville near the intersection of Sutton Road and the Kingston and Dallas Turnpike. His wife, Sarah Woolbert, became president of the ladies' aid society of the Trucksville Methodist Episcopal Church on April 16, 1895. After this 1900s photograph was taken, the Kingston and Dallas Turnpike was expanded to accommodate more traffic in the Back Mountain. (Courtesy of Louise Schooley Hazeltine.)

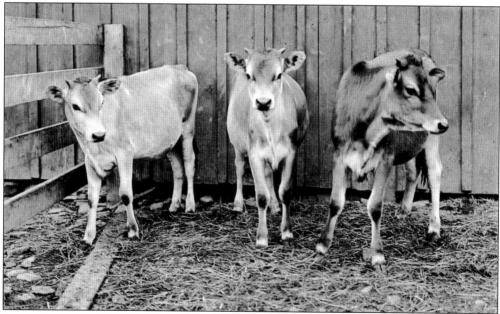

JERSEY CALVES AT HILLSIDE FARMS, 1900S. The development of Hillside Farms as a commercial dairy came with the introduction of Jersey and Holstein-Friesian cows imported from Europe before 1900. In 1977, Hillside Farms built the dairy store on Hillside Road. In 2007, the Lands at Hillside Farms reintroduced a milking herd of Jersey cows, creating a new line of dairy products. (Courtesy of the Lands at Hillside Farms.)

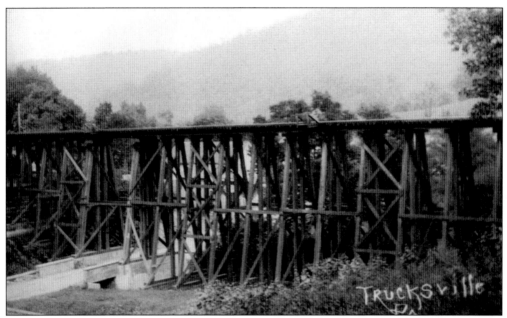

TROUT RUN TRESTLE, C. 1910. This view was taken from the Kingston and Dallas Turnpike in Trucksville. The main road through Kingston Township was laid out in 1802 and became the Kingston and Dallas Turnpike in 1870. Railroad and trolley service increased the population of Kingston Township. The Bowman's Creek branch of the Lehigh Valley Railroad offered efficient transportation and freight service in the Back Mountain. (Courtesy of Jack Martin.)

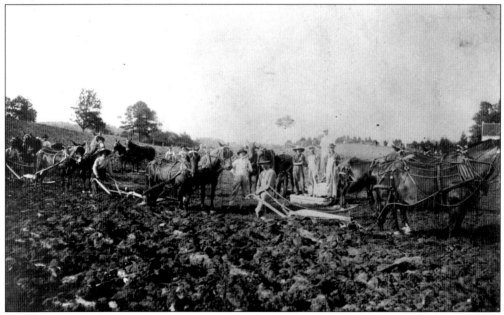

HILLSIDE FARMS, C. 1904. This view of the farms located near the Trucksville Methodist Episcopal Church shows seven teams working together to plow a field. This photograph was taken near Church Street with the church and cemetery in the background on the right. It was taken before the church was remodeled in 1906. Hillside Farms often hired farmers from Kingston Township to plow fields during planting season. (Courtesy of Louise Schooley Hazeltine.)

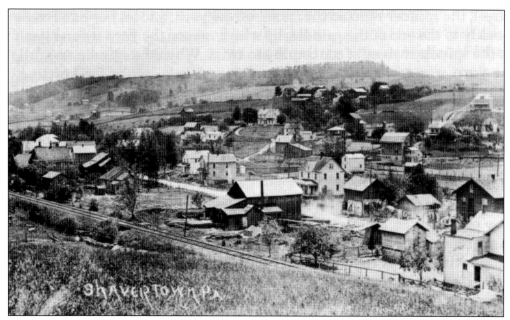

SHAVERTOWN LOOKING TOWARD DALLAS, 1904. The railroad tracks are seen in the foreground. Shavertown was named for Philip Shaver (1762–1826), who was born in Austria and settled in Forty Fort. In 1813, he purchased lot No. 3 of the certified Bedford Township. Shaver purchased 1,000 acres surrounding Shavertown in 1815, and his family owned much of Shavertown into the 1900s. (Courtesy of Pauline Shaver Roth.)

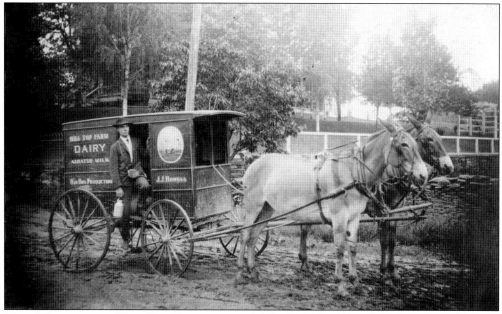

MILK WAGON FROM HILL TOP FARM, C. 1905. The Hill Top Farm Dairy was owned by J. J. Howell in the Harris Hill section of Trucksville, and the dairy delivered milk throughout the area. This photograph shows his son, Gideon L. Howell, delivering milk. Dr. Gideon L. Howell became the first physician to practice in Trucksville after the death of Dr. James Rowley Lewis (1804–1883). (Courtesy of Louise Schooley Hazeltine.)

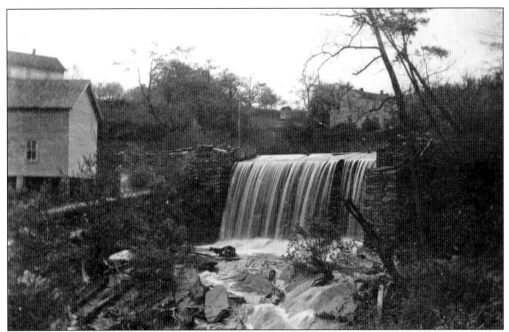

TOBY'S CREEK FALLS, 1900S. On December 21, 1773, a meeting in Kingston appointed Nathaniel Landon, Nathan Denison (1741–1809), and William Gallup to survey Toby's Creek for potential building sites for a gristmill and sawmill. Ruins of the mill built by William Trucks in the early 1800s were evident at the Toby's Creek falls. (Courtesy of Louise Schooley Hazeltine.)

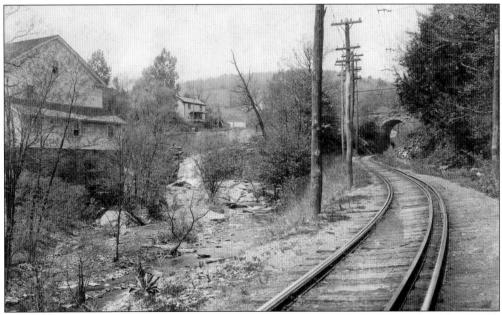

TROLLEY TRACKS LEADING TO THE HARRIS HILL ROAD UNDERPASS, 1905. The Toby's Creek falls appear on the left. John B. Reynolds chartered the Wilkes-Barre and Northern Railroad on January 29, 1896. Regular trolley service between Wilkes-Barre and Harvey's Lake started on June 27, 1897. The railroad was reorganized in 1898 as the Wilkes-Barre, Dallas and Harvey's Lake Railway Company. (Courtesy of Louise Schooley Hazeltine.)

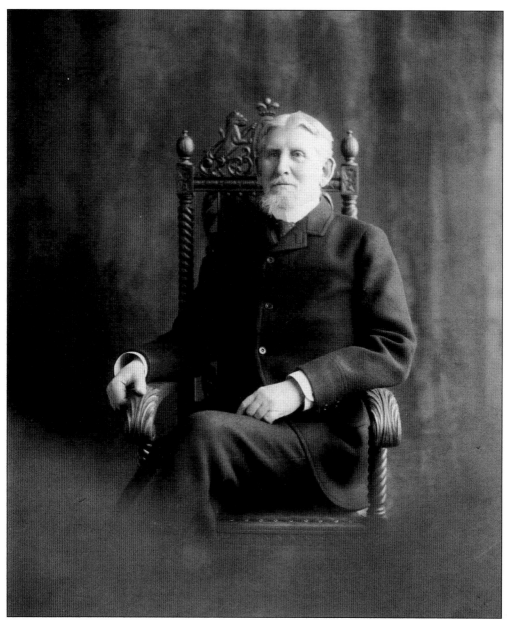

WILLIAM L. CONYNGHAM. William L. Conyngham, the founder of Hillside Farms, is pictured shortly before his death in 1907. His parents were John N. Conyngham (1798–1871) and Ruth Ann Butler Conyngham. John N. Conyngham came to Wilkes-Barre in 1820 after graduating from the University of Pennsylvania. He was appointed the presiding judge of the Luzerne County Court of Common Pleas, a position he held from 1841 to 1870. In 1829, William L. Conyngham was born in Wilkes-Barre. He married Olivia Hillard from Charleston, South Carolina. William L. Conyngham was a coal broker in the firms of Parrish and Conyngham and Conyngham and Paine in Wilkes-Barre. He was partners with Joseph Stickney, whose company supplied coal to residents in Illinois, Maryland, Massachusetts, Missouri, New York, and Pennsylvania. The Conyngham family lived on South River Street in Wilkes-Barre. (Courtesy of the Lands at Hillside Farms.)

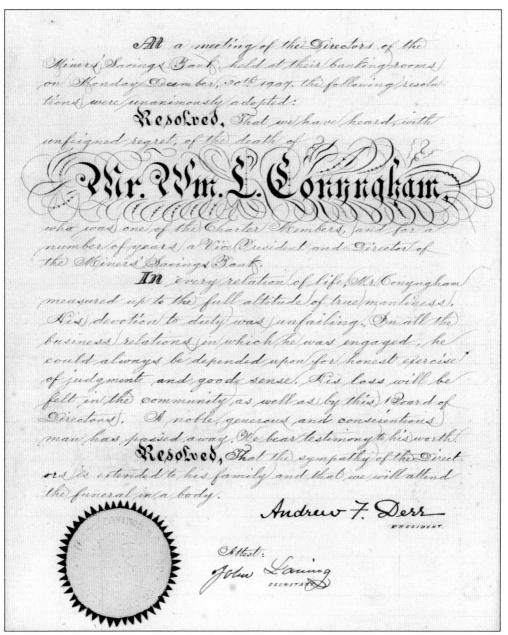

CONYNGHAM TRIBUTE. After the death of William L. Conyngham, the directors of the Miners Savings Bank in Wilkes-Barre drafted this tribute to him on December 30, 1907. William L. Conyngham was a charter member of the Miners Savings Bank and served as vice president and director of the bank. His widow, Olivia Hillard Conyngham, lived on South River Street until her death in 1918. The home of the Religious Sisters of Mercy at St. Mary's Convent on Washington Street in Wilkes-Barre was destroyed by fire on March 21, 1920. The Religious Sisters of Mercy resided at the house of the late Olivia Hillard Conyngham on South River Street until the Administration Building at College Misericordia was completed. The sons of William L. Conyngham and Olivia Hillard Conyngham owned farmland in the Back Mountain. (Courtesy of the Lands at Hillside Farms.)

HILLSIDE ROAD, 1907. This postcard shows Hillside Road near the Wilkes-Barre Water Company filter plant and Sutton Road on the hill in the background. Hillside Road connected Hillside Farms to the Kingston and Dallas Turnpike and was close to the Hillside trolley station. William H. Conyngham raised horses and cows at Hillside Farms, and John N. Conyngham II founded Hayfield Farm and raised Clydesdales in Lehman. (Courtesy of Howard and Lillian Gola.)

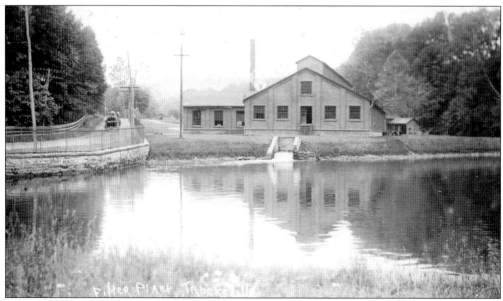

WILKES-BARRE WATER COMPANY FILTER PLANT, 1912. Hillside Road is on the left looking toward Hillside Farms. Water flowed from the Huntsville reservoir to the filter plant to improve the water supply in the Wyoming Valley. The building was completed in 1895, close to the Kingston and Dallas Turnpike. The Hillside trolley station was built nearby. (Courtesy of Howard and Lillian Gola.)

VIEW OF 19-ACRE FIELD AT HILLSIDE FARMS. The Cliffside section of Trucksville is in the background. This photograph from the second decade of the 20th century was taken from Sutton Road. Improved roads and access to railroad and trolley transportation made it easier for families to live in the Back Mountain. Many people moved to the area, and summer homes were often converted into year-round homes. Hillside Farms had grown into a considerable agricultural estate by this time and owned many properties in Trucksville where employees could live. (Courtesy of Louise Schooley Hazeltine.)

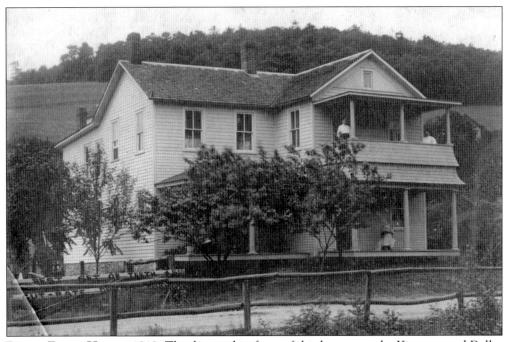

BYRON EVANS HOUSE, 1910. The dirt road in front of this house was the Kingston and Dallas Turnpike near the intersection of Pioneer Avenue and Sutton Road. The basement of the house was used by the Evans Dairy. The trolley line and railroad tracks passed by the property, and Toby's Creek ran in front of the house. Note the dentistry advertisement. (Courtesy of Albert Billings.)

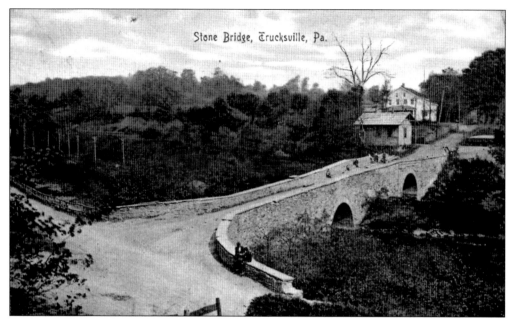

HARRIS HILL ROAD STONE BRIDGE, C. 1910. This postcard shows the Lehigh Valley Railroad station in Trucksville next to the house built by Dr. James Rowley Lewis, who came from Schoharie County, New York, in 1829. The Harris Hill Road stone bridge was built with two arches; one was an underpass for the trolley line, and Toby's Creek was diverted through the second arch. (Courtesy of Louise Schooley Hazeltine.)

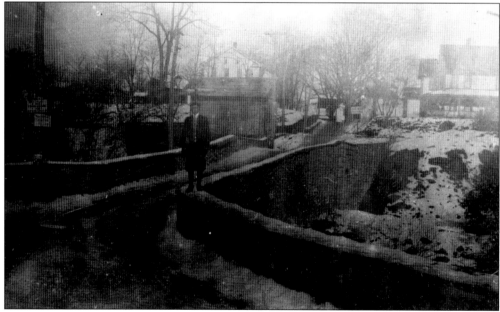

SHERMAN SCHOOLEY, C. WINTER 1910. Sherman Schooley (1899–1952) is seen standing on the Harris Hill Road stone bridge in Trucksville at the intersection with the Kingston and Dallas Turnpike. The bridge was later reinforced with concrete. Schooley opened a medical practice on West Center Street in Shavertown. By the late 1930s, the major roads in Kingston Township were paved, and the trolley tracks were removed. (Courtesy of Louise Schooley Hazeltine.)

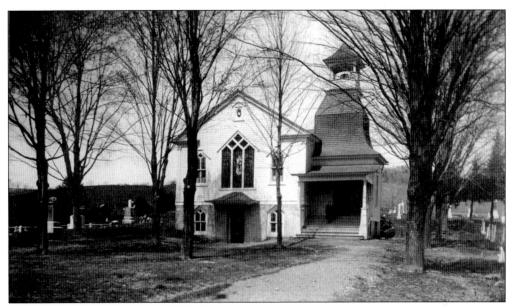

TRUCKSVILLE METHODIST EPISCOPAL CHURCH. The remodeled Trucksville Methodist Episcopal Church was dedicated on February 24, 1907. The church was built on property donated by Jacob and Sarah Rice and was organized on March 9, 1844. The belfry was added in 1890. During the remodeling of the church in 1906, the belfry was moved, a basement was added, and the entrance was moved under the belfry to enlarge the sanctuary. (Courtesy of Louise Schooley Hazeltine.)

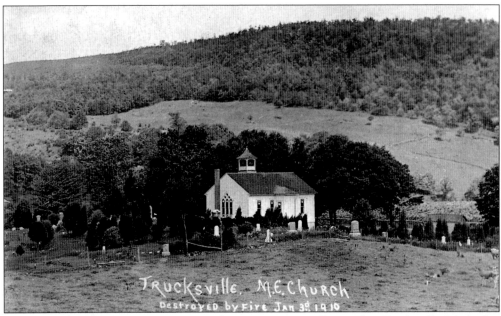

TRUCKSVILLE METHODIST EPISCOPAL CHURCH BEFORE FIRE. The Trucksville Methodist Episcopal Church on Church Road was destroyed by fire on January 3, 1910. This photograph was taken from the fields at Hillside Farms. Before the church was built in 1844, the congregation was organized in a Methodist class. The class leader was responsible for raising funds to support the church and was often licensed to preach. (Courtesy of Stephen B. Killian.)

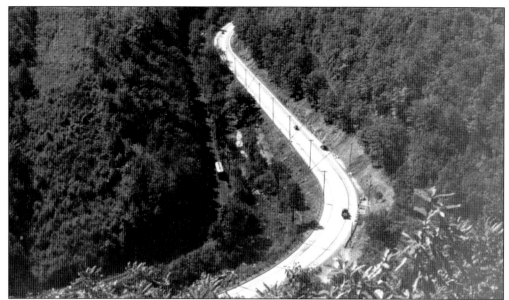

WILKES-BARRE RAILWAY CORPORATION TROLLEY NO. 360. Trolley No. 360 is seen traveling along Toby's Creek between Luzerne and the Birch Grove station in Kingston Township. This photograph was taken by Edward S. Miller on September 26, 1938, and shows Toby's Creek between the trolley tracks and the paved road before the highway was constructed. The Lehigh Valley Railroad tracks appear to the right of the paved road. (Courtesy of the Edward S. Miller collection.)

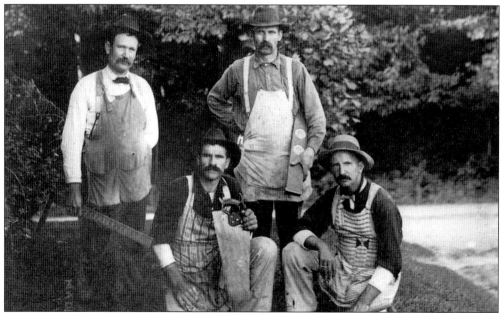

CARPENTERS AT CONSTRUCTION SITE OF THE TRUCKSVILLE METHODIST EPISCOPAL CHURCH, 1910. This image includes, from left to right, contractor William J. Robbins, Wesley Morton, John Hegaman, and Asa P. Shaver. The building was constructed at the same location as the original church on Church Road. William J. Robbins supervised the construction of many buildings throughout Kingston Township. (Courtesy of Louise Schooley Hazeltine.)

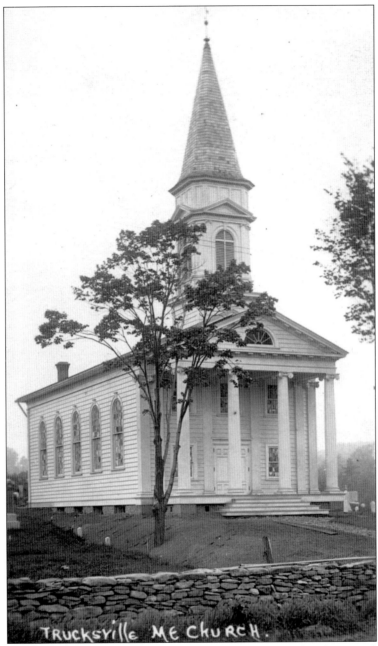

TRUCKSVILLE METHODIST EPISCOPAL CHURCH, 1911. The church was dedicated on January 26, 1911. From 1818 to 1915, class leaders were responsible for supporting the church and congregation. Early class leaders included Jacob Rice, John P. Rice, James Patterson, William L. Rice, William C. Faulkner, Samuel R. Hess, J. P. Benning, M. J. Nafus, Thomas Carle Jr., and Lewis W. Roushey. Between 1906 and 1940, the ladies' aid society raised funds to maintain the church, especially after the original church was destroyed by fire in 1910. The ladies' aid society was replaced by the Women's Society for Christian Service. In 1932, a new addition to the back of the Trucksville Methodist Episcopal Church was built to accommodate the organ donated by the Conyngham family. (Courtesy of the FCP collection.)

JOSEPH BULFORD BLACKSMITH SHOP, 1914. Joseph Bulford (1876–1948) owned a blacksmith shop on the Kingston and Dallas Turnpike in Trucksville. He purchased the shop from John Space. This photograph includes, from left to right, Thelma Bulford, Robert Bulford, James Stevens, and Joseph Bulford. Robert Bulford was a veteran of World War I. Joseph Bulford sold hardware, shoed horses, and repaired wagons. Note the automobile in the garage; he also sold gasoline and serviced automobiles. (Courtesy of Louise Schooley Hazeltine.)

WILLIAM C. JOHNSON HOUSE, 1912. William C. Johnson (1865–1928) built this house on Carverton Road in Trucksville. He lived next door to Dr. Gilbert L. Howell. William C. Johnson was postmaster of Trucksville from 1907 to 1908 and served as the Kingston Township school director. He ran the post office out of his general store on the corner of Carverton Road and the Kingston and Dallas Turnpike. (Courtesy of Elizabeth Spaciano.)

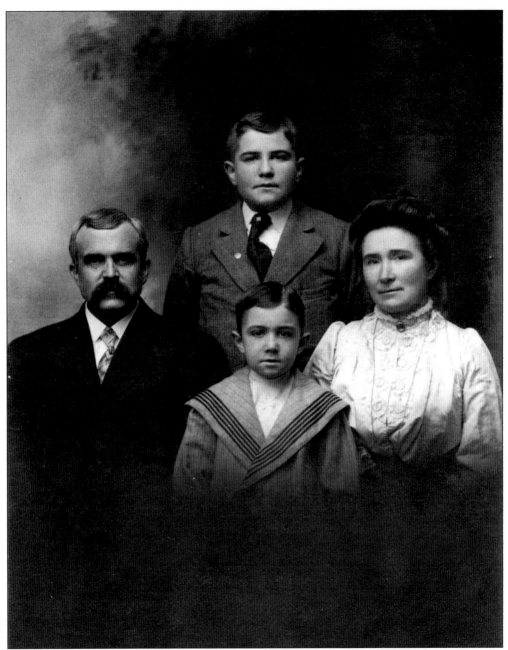

JOHNSON FAMILY, TRUCKSVILLE, C. 1910. This photograph includes William C. Johnson and his wife, Jennie Coolbaugh Johnson, and their sons, Benjamin Ford Johnson (back) and Arthur Clyde Johnson (front). William C. Johnson married Jennie Coolbaugh on March 27, 1890. Benjamin Ford Johnson was born in 1893, and Arthur Clyde Johnson was born in 1901. The family lived in Lehman where William C. Johnson owned a general store. In 1895, William Neely built a general store at the intersection of Carverton Road and the Kingston and Dallas Turnpike in Trucksville. Before 1900, William Neely traded businesses with William C. Johnson, and William Neely moved to Lehman. William C. Johnson moved his family to Trucksville, and he operated the general store built by William Neely. (Courtesy of Joan Coolbaugh Britt.)

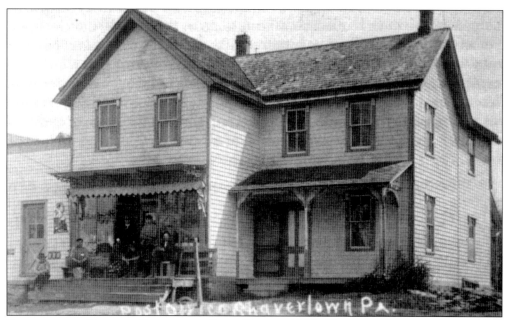

SHAVERTOWN GENERAL STORE AND POST OFFICE, 1908. The general store and post office were located on the corner of East Center Street and Old Main Road. Edward Travis owned the store and served as postmaster from 1907 to 1911. The store was close to the Kingston and Dallas Turnpike and was one of the few stores in Shavertown until Hall's Drug Store and the Fairlawn store opened. (Courtesy of Pauline Shaver Roth.)

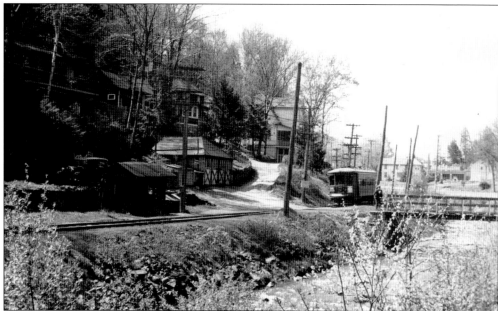

WILKES-BARRE RAILWAY CORPORATION TROLLEY NO. 788. Trolley No. 788 is shown near the Birch Grove station in Kingston Township. In the background is the intersection of Hillside Road and the Kingston and Dallas Turnpike. This photograph was taken by Edward S. Miller on May 1, 1938. The trolley tracks were next to Toby's Creek. The Kingston and Dallas Turnpike was across the bridge on the right. (Courtesy of the Edward S. Miller collection.)

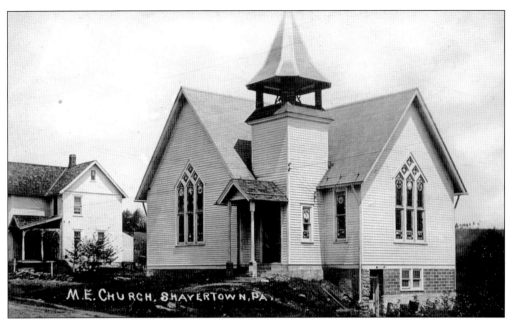

SHAVERTOWN METHODIST EPISCOPAL CHURCH. The Shavertown Methodist Episcopal Church was chartered in 1890, and early services were held in the one-room schoolhouse on West Center Street. Property for the church was donated by Theron Ferguson on the corner of West Center Street and Pioneer Avenue. The cornerstone was laid on November 5, 1903. The church cost $3,724.58 to build and was dedicated on December 21, 1904. (Courtesy of the FCP collection.)

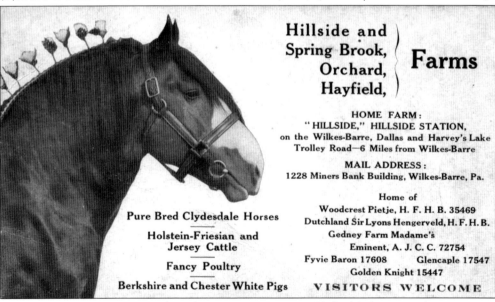

LIVESTOCK ADVERTISEMENT. This advertisement promotes Clydesdale horses, Holstein-Friesian and Jersey cows, poultry, and Berkshire and Chester White pigs raised at Back Mountain farms including Hillside Farms, Spring Brook Farm, Orchard Farm, and Hayfield Farm. These farms were open to the public and accessible by train and trolley. Hillside Farms purchased the thoroughbred Clydesdale Fyvie Baron, pictured in this advertisement, for $6,500 in 1913. The Clydesdale Golden Knight was raised at Hayfield Farm. (Courtesy of the Lands at Hillside Farms.)

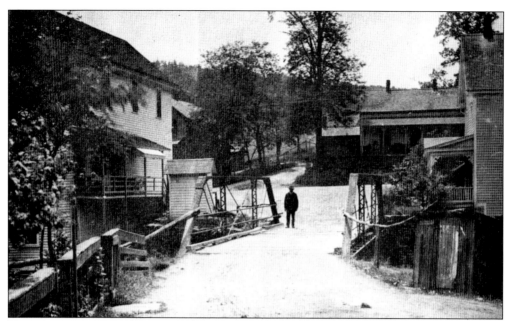

TRUCKSVILLE, 1915. This postcard shows the Carverton Road iron bridge over Toby's Creek and the intersection of Church Road and the Kingston and Dallas Turnpike. The William C. Johnson general store is the large building on the left. One of the largest mills on Toby's Creek in Trucksville was the Rice and Bisher gristmill built in 1830. The gristmill was later called Isaac Rice's mill. (Courtesy of Louise Schooley Hazeltine.)

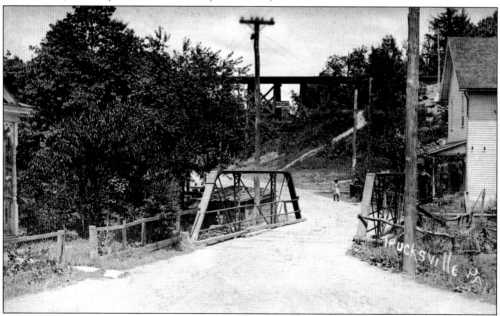

CARVERTON ROAD IRON BRIDGE LOOKING TOWARD THE TROUT RUN TRESTLE, 1915. The building on the right served as the municipal building, and the Trucksville Volunteer Fire Company held its first committee meeting there on January 21, 1918. The meeting was attended by Thomas R. Hughes, Leo C. Jones, M. E. Keeler, Joseph Bulford, Everett G. Besteder, and Robert J. Patterson. (Courtesy of Howard and Lillian Gola.)

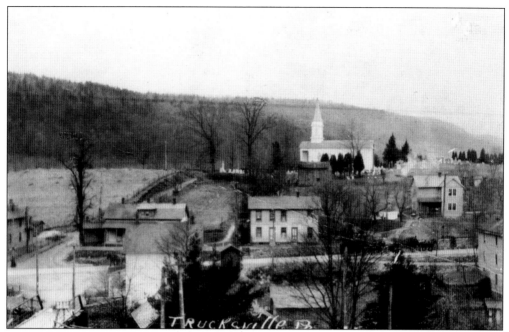

TRUCKSVILLE METHODIST EPISCOPAL CHURCH, 1916. Jacob R. Shaver owned a general store on the Kingston and Dallas Turnpike while he was postmaster of Trucksville from 1889 to 1893. William H. Patterson and his son Robert J. Patterson later operated the general store until Robert's death in 1918 during the influenza epidemic. (Courtesy of Louise Schooley Hazeltine.)

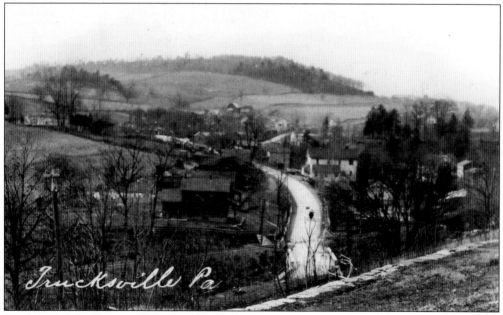

KINGSTON AND DALLAS TURNPIKE BETWEEN HILLSIDE ROAD AND CARVERTON ROAD. The turnpike is going toward Dallas with the trolley crossing and the bridge over Toby's Creek in the foreground. This 1916 photograph was taken near the Cliffside section of Trucksville. The Everett G. Besteder house and the William C. Johnson general store are on the right, and the houses on the left were owned by Hillside Farms. (Courtesy of Louise Schooley Hazeltine.)

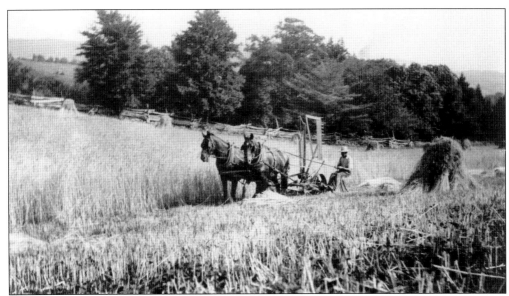

JOSEPH B. SCHOOLEY, 1915. Joseph B. Schooley is at the Hill Brook Farm with his draft horses Dick and Dan near the Harris Hill section of Trucksville. He operated the Schooley farm on Harris Hill Road that was owned by Jacob and Esther Delay, who were the first to clear and cultivate the land. In 1923 and 1924, Joseph B. Schooley was the Kingston Township school director. (Courtesy of Louise Schooley Hazeltine.)

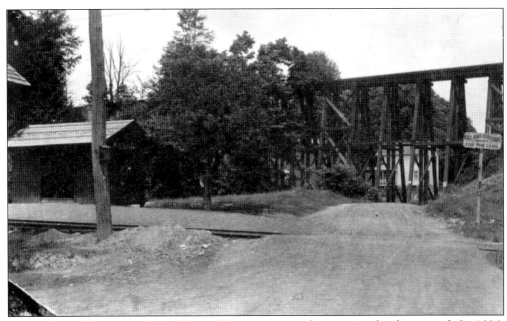

TROUT RUN TRESTLE, 1920s. The trolley station can be seen in the foreground. In 1926, the Luzerne County government started maintaining Carverton Road. The 10-foot span at the bottom of the trestle was widened, and the wooden bridge under trestle was replaced with a concrete bridge. The trestle was removed after the Bowman's Creek branch of the Lehigh Valley Railroad was abandoned. (Courtesy of Louise Schooley Hazeltine.)

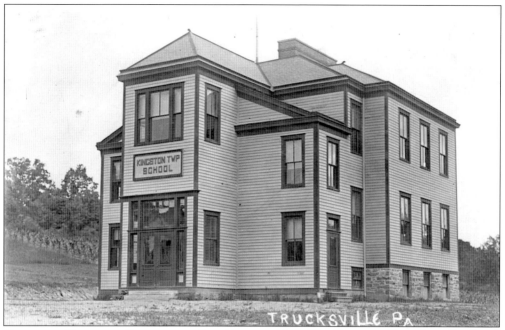

KINGSTON TOWNSHIP SCHOOL ON OAK STREET, 1913. The Kingston Township school was built in 1906 for the junior high school and high school. In 1917, a four-room addition was built for the elementary school. Two more rooms were added in 1926. The building was destroyed by fire on December 12, 1937. In 1938, the new construction of the building was partially funded by the Works Progress Administration. (Courtesy of the FCP collection.)

The Class of 1924
The Kingston Township
High School
announces the
Commencement Exercises
on Friday, the Sixth of June
eight o'clock
Trucksville M. E. Church

KINGSTON TOWNSHIP HIGH SCHOOL GRADUATES, 1924. The 1924 graduates of Kingston Township High School included Christina Sword, Audrey L. Carle, Jane Voight, Frances Fisher, Rebecca C. Kulp, Charlotte E. Cease, Irene Besteder, Bertha M. Sutliff, Rachel A. Coursen, Blanche E. Moore, Kenneth J. Woolbert, Maud E. Nulton, Arlene R. Coolbaugh, Elizabeth H. Gay, Mabel Major, Helen E. Hazeltine, Howard H. Woolbert, Henry Brace, Nelson A. Woolbert, Charles W. DeWitt, and Zeba H. Hefft. (Courtesy of Joan Coolbaugh Britt.)

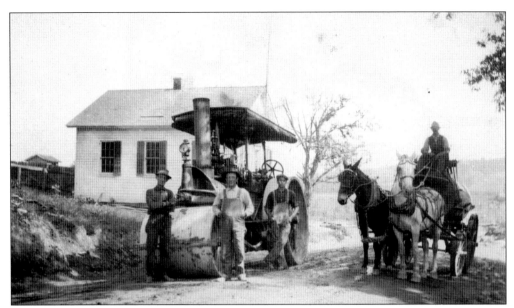

KINGSTON TOWNSHIP ROAD CREW, 1920S. The crew is busy paving a road, and the Kingston Township road crew supervisor, Wesley David Sutton, drives the team of horses. The road crew used this steamroller until the early 1930s. As automobiles became prevalent in the 1920s and 1930s, major roads in Kingston Township were paved before the highway was constructed. (Courtesy of Louise Schooley Hazeltine.)

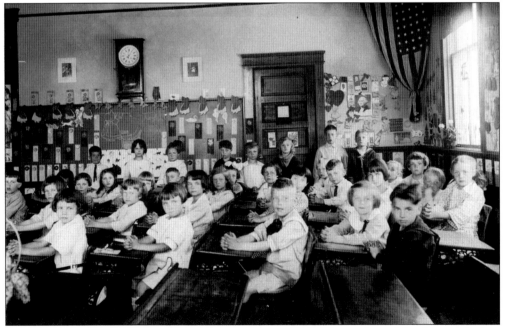

KINGSTON TOWNSHIP SCHOOL FIRST-GRADE CLASS, 1925. The teacher of this first-grade class in Trucksville was Emeline Schooley Hazeltine. She married Ralph Hazeltine in 1922 and retired from teaching in 1948. The photograph includes her niece Marian Schooley and nephew Carl Stock Jr. The last one-room schoolhouse in Kingston Township was in the Bunker Hill section of Trucksville, and it closed in 1928. (Courtesy of Louise Schooley Hazeltine.)

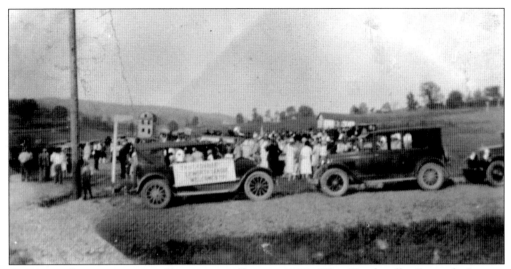

OPENING CEREMONY FOR CARVERTON ROAD, 1927. The Trucksville Epworth League sponsored the opening ceremony for Carverton Road, which was located between Trucksville and west Wyoming. This photograph was taken near the Daniel Heft sawmill on Abraham's Creek that was demolished when the Frances Slocum State Park dam was constructed. Frances Slocum (1773–1847) was abducted near Abraham's Creek by members of the Lenape tribe on November 2, 1778. In 1837, her brothers found her living with her new family on a reservation in Indiana. (Courtesy of the Misericordia University Archives.)

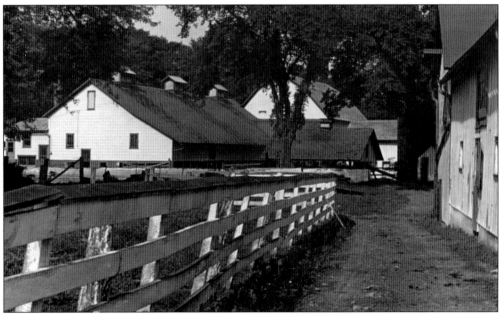

BARNS AND BUILDINGS AT HILLSIDE FARMS, 1930S. Several of these barns were built in the early 1900s by William J. Robbins and his carpenters John Hegaman, Wesley Morton, and Asa P. Shaver, who built the Trucksville Methodist Episcopal Church in 1910. The barns were used for livestock and to store farm equipment at Hillside Farms. (Courtesy of the Lands at Hillside Farms.)

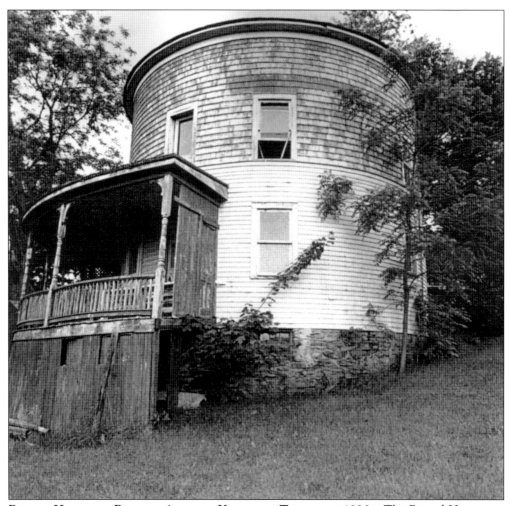

ROUND HOUSE ON PIONEER AVENUE, KINGSTON TOWNSHIP, 1930S. The Round House was built in the late 1800s as a silo for the house across Pioneer Avenue. It was converted into a two-bedroom house and was later owned by the Adams family. The Round House was known for its distinct architecture and circular rooms. After being vacant for several years, it was razed in 1991. Many water-powered industries were built along Toby's Creek. In 1833, a tannery was built near the intersection of Carverton Road and the Kingston and Dallas Turnpike. The tannery was later owned by Patrick DeLacey, who enlisted in the 143rd Pennsylvania Volunteer Infantry Regiment Company A in 1861. He became captain of his company, and on April 24, 1894, he was awarded the Congressional Medal of Honor for bravery under fire at the Battle of the Wilderness in Virginia on May 6, 1864. (Courtesy of the Misericordia University Archives.)

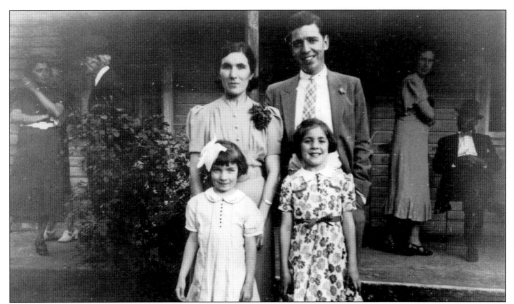

WESLEY DAVID SUTTON'S 76TH BIRTHDAY. The Coolbaugh family is pictured at the 76th birthday party of Laing K. Coolbaugh's grandfather Wesley David Sutton on June 5, 1938. The photograph shows Eleanor Scott Coolbaugh and her husband, Laing K. Coolbaugh, with their daughters, Joan Coolbaugh Britt (left) and Eleanor Jane Coolbaugh Plummer (right). This photograph was taken at the Sutton farm on the front porch of Wesley David Sutton's house on Sutton Road in Trucksville. (Courtesy of Joan Coolbaugh Britt.)

BRIDGE OVER TOBY'S CREEK, C. 1938. This bridge was located on the Kingston and Dallas Turnpike going toward Dallas between Hillside Road and Carverton Road in Trucksville. This photograph shows the trolley tracks crossing the Kingston and Dallas Turnpike near the bridge and the house owned by Everett G. Besteder. Many buildings along Toby's Creek in Trucksville were razed during the construction of the highway. (Courtesy of Louise Schooley Hazeltine.)

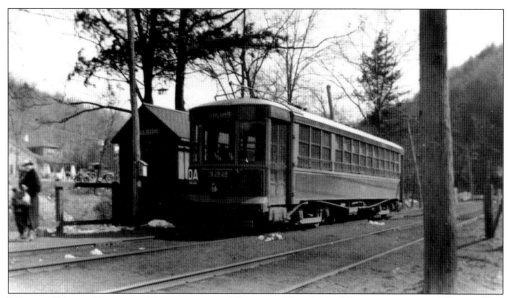

WILKES-BARRE RAILWAY CORPORATION TROLLEY NO. 322, MARCH 1, 1938. This trolley, pictured at the Hillside trolley station in Trucksville, was bound for Dallas, where passengers could take the bus to Harvey's Lake. In 1931, trolley service from Dallas to Harvey's Lake was discontinued. The Hillside trolley station was located close to Toby's Creek and the Kingston and Dallas Turnpike. (Courtesy of the Edward S. Miller collection.)

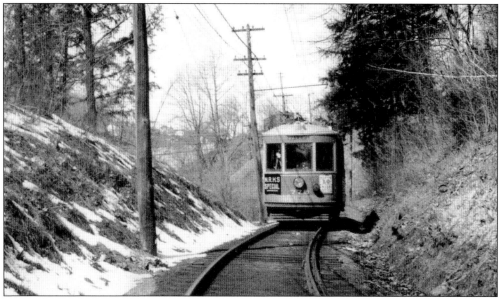

WILKES-BARRE RAILWAY CORPORATION TROLLEY NO. 778. This trolley was photographed between Shavertown and Trucksville after going through the Harris Hill Road underpass in Trucksville. This was a special excursion trolley for the National Railway Historical Society in 1938. In 1933, trolley No. 778 was delivered secondhand to the Wilkes-Barre Railway Corporation. The trolley company became the Wilkes-Barre Transit Corporation on August 29, 1947. (Courtesy of the Edward S. Miller collection.)

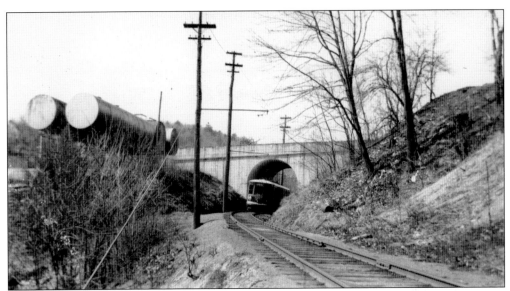

WILKES-BARRE RAILWAY CORPORATION TROLLEY NO. 332, MARCH 25, 1938. This photograph shows the underpass of the Harris Hill Road concrete bridge after the stone bridge was rebuilt and the second arch was removed. Toby's Creek was diverted through the arch after trolley service was discontinued and the trolley tracks were removed. (Courtesy of the Edward S. Miller collection.)

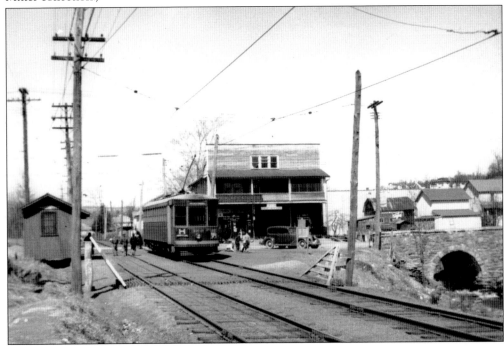

WILKES-BARRE RAILWAY CORPORATION TROLLEY NO. 328, SHAVERTOWN STATION. This trolley is seen on March 25, 1938, at the Center Street crossing next to the Fairlawn store. After the trolley tracks were removed, this became part of the highway. The Shavertown Shopping Center was built on the left. The Shaver movie theater was behind the Fairlawn store, and the theater became the Snowdon Funeral Home. (Courtesy of the Edward S. Miller collection.)

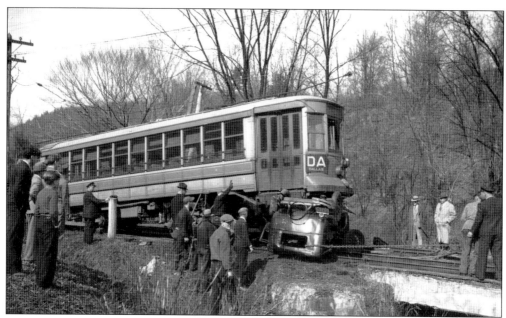

ACCIDENT ON THE LAST DAY OF TROLLEY SERVICE TO DALLAS, APRIL 30, 1939. Wilkes-Barre Railway Corporation trolley No. 356, bound for Dallas, collided with an automobile at the Mount Greenwood crossing in Kingston Township. Note the chain attached to the wrecked automobile. Emergency trolley No. 390 was on the scene to remove the wreck from underneath the trolley. (Courtesy of the Edward S. Miller collection.)

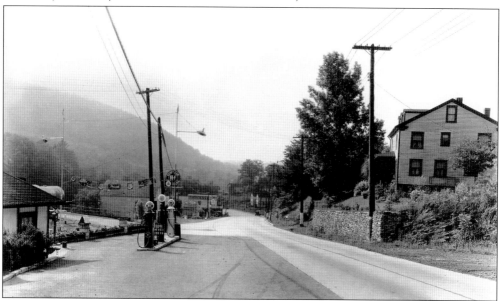

SCENE OF A HIT-AND-RUN ACCIDENT, 1930s. Trolley operator Johnson Van Buren Coolbaugh was struck by an automobile at the intersection of the Kingston and Dallas Turnpike, Pioneer Avenue, and Harris Hill Road. This photograph was taken from Sutton Road intersection with Pioneer Avenue and shows the storefronts and buildings between Harris Hill Road and Carverton Road. From 1933 to 1938, the service station was owned by Fred Woolbert. (Courtesy of Joan Coolbaugh Britt.)

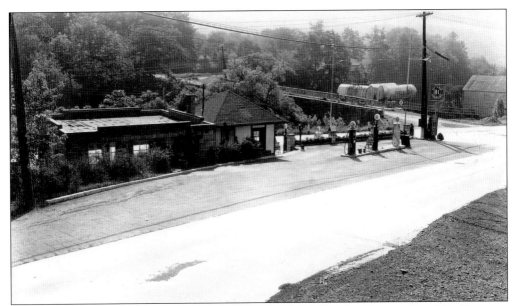

SERVICE STATION, C. 1934. This service station was located at the intersection of the Kingston and Dallas Turnpike, Pioneer Avenue, and Harris Hill Road. Fred Woolbert sold Sinclair gasoline from pumps on Pioneer Avenue and pumps on the Kingston and Dallas Turnpike. The service station was later operated by Harry Martin and his son Jack Martin. This photograph was taken after major roads between Luzerne and Dallas were paved. (Courtesy of Joan Coolbaugh Britt.)

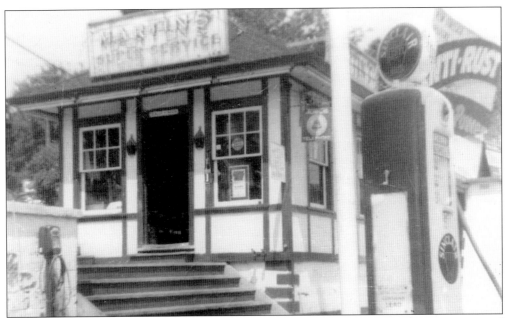

MARTIN'S SERVICE STATION, C. 1948. Martin's Service Station was near the intersection of Pioneer Avenue, the Kingston and Dallas Turnpike, and Harris Hill Road. Harry and Jack Martin operated the service station from 1947 to 1955. The service station was across Harris Hill Road from the Trucksville feed mill. Martin's Service Station and the Trucksville feed mill were removed to construct the highway. (Courtesy of Jack Martin.)

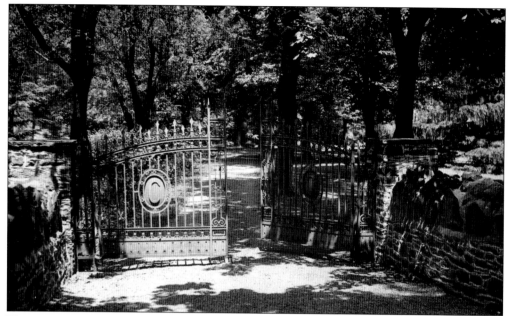

HILLSIDE FARMS GATE, 1940S. This gate leads to the park and greenhouses at Hillside Farms. Identical sets of wrought iron gates were installed across from each other on Hillside Road. The park along Toby's Creek was created in memory of William L. Conyngham and his wife Olivia Hillard Conyngham. Across Hillside Road, the other set of new gates led to the Hillside Cottage. (Courtesy of the Lands at Hillside Farms.)

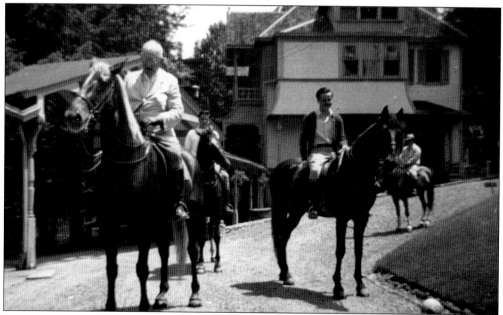

MORNING RIDE. William H. Conyngham is pictured on a Sunday morning ride with his sons Jack and Guthrie at Hillside Farms. This c. 1940 photograph was taken in front of the cottage annex connected to the Hillside Cottage by the covered walkway on the left. This photograph shows Ted Hoover, who was the family chauffeur and groomed the horses. The cottage annex was razed before 1960. (Courtesy of the Lands at Hillside Farms.)

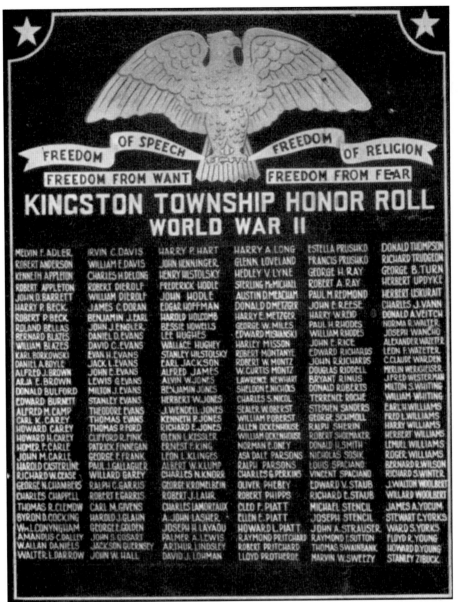

KINGSTON TOWNSHIP HONOR ROLL FOR WORLD WAR II SOLDIERS. The Kingston Township honor roll plaque was dedicated at the Kingston Township High School auditorium in Trucksville on February 22, 1943. The veterans on the plaque include Melvin Adler, Robert Anderson, Kenneth Appleton, John Barrett, Roland Bellas, William Blazes, Karl Borkowski, Daniel Boyle, Alfred Brown, Donald Bulford, Edward Burnett, Alfred Camp, Carl Carey, Howard Carey, Harold Casterline, Richard Cease, George Chambers, Charles Chappell, Thomas Clemow, Byron Cocking, William L. Conyngham, Walter Darrow, Irvin Davis, James Doran, John Engler, Daniel Evans, Thomas Evans, Paul Gallagher, Robert Garris, John Hall, John Henninger, Edgar Hoffman, Bessie Howells, Earl Jackson, Alvin Jones, Ernest King, Charles Knorr, Harry Long, Ralph Parsons, Estella Prushko, Francis Prushko, Paul Rhodes, Robert Shoemaker, Vincent Spaciano, Edward Staub, Raymond Sutton, Walton Woolbert, James Yocum, and Howard Young. (Courtesy of Joan Coolbaugh Britt.)

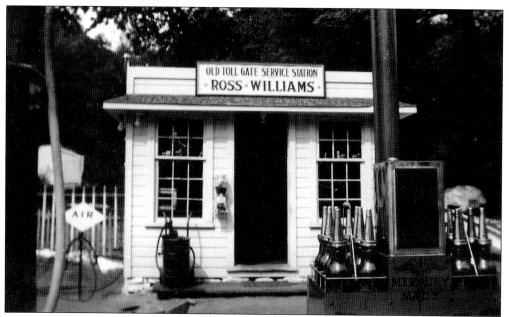

OLD TOLL GATE SERVICE STATION, 1940s. The Old Toll Gate Service Station was owned by Ross Williams and located near the rock cut on the Kingston and Dallas Turnpike. His son, Ross Williams Jr., graduated from the Kingston Township High School in 1942. The Kingston and Dallas Turnpike was incorporated as a toll road on April 16, 1870. The service station was next to the Old Toll Gate Feed Mill. (Courtesy of Stephen B. Killian.)

HILLSIDE FARMS GREENHOUSE, 1940s. The greenhouse conservatory was originally built near the Conyngham residence in Wilkes-Barre. After the death of Olivia Hillard Conyngham, the greenhouse conservatory was moved to Hillside Farms near the park along Toby's Creek. For many years, the greenhouse was maintained by horticulturalist Howard Ide. (Courtesy of the Lands at Hillside Farms.)

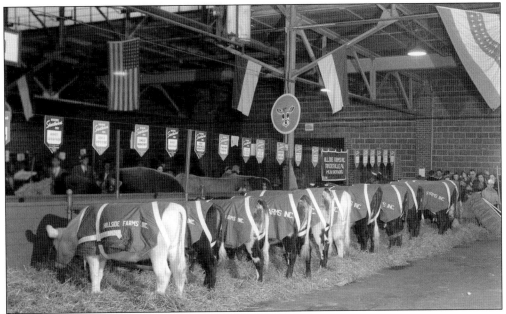

MILKING SHORTHORNS FROM HILLSIDE FARMS. This photograph was taken at the Pennsylvania Farm Show in Harrisburg by the Strohmeyer and Carpenter Studio. Hillside Farms incorporated 400 acres in Kingston Township after purchasing the Sutton farm on Sutton Road in 1946. The Sutton farm was originally called the Charles Smith farm. This was the last real estate purchase made by Hillside Farms. (Courtesy of the Lands at Hillside Farms.)

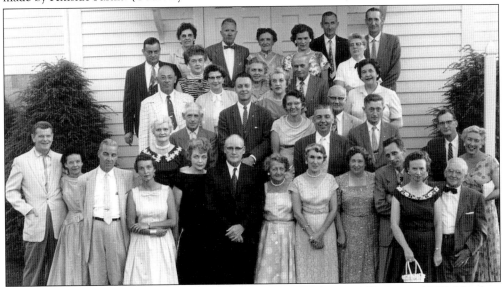

THE 1957 REUNION OF THE KINGSTON TOWNSHIP HIGH SCHOOL CLASS OF 1927. Members of the Kingston Township High School class of 1927 pose in front of the Jackson Methodist Episcopal Church. The photograph includes Tyrus Carr, Daniel Richards, D. W. Evans, Frank Jahn, Eleanor Scott Coolbaugh, Laing K. Coolbaugh, Machell Hildebrant, Lulu Anderson, Frank Stroud, Wilson Cease, Clarence Adams, Norton Newberry, Arlene Covert, Marian Young, Adam Young, Marian Oliver, Erma Culp, Robert Culp, Sherman Hefft, and Frank Kurfess. (Courtesy of Joan Coolbaugh Britt.)

COMPLETED HIGHWAY BETWEEN KINGSTON TOWNSHIP, DALLAS BOROUGH, AND DALLAS TOWNSHIP, 1960S. This photograph shows the Trucksville United Methodist Church cemetery on Church Road in the lower left. New construction along the Dallas Memorial Highway razed many buildings and homes in Kingston Township. The Trucksville Volunteer Fire Company used several vacated properties on the highway scheduled for demolition to train new firefighters on how to put out fires. Construction of the highway was completed after the removal of the

Bowman's Creek branch of the Lehigh Valley Railroad and the Trout Run trestle. The completed highway improved access to the Wyoming Valley. While farms had once dominated the area, the population of the Back Mountain grew rapidly after the 1972 flood caused by Hurricane Agnes that devastated the Wyoming Valley and many areas in Pennsylvania. (Courtesy of the Luzerne County Historical Society.)

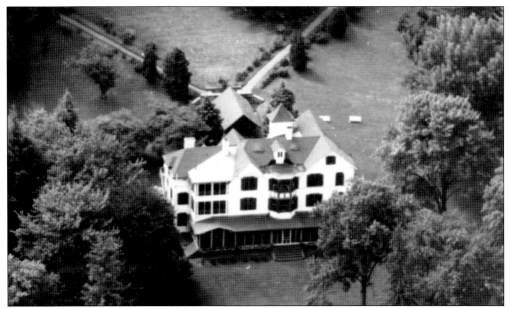

AERIAL PHOTOGRAPH OF THE HILLSIDE COTTAGE, 1940S. The Hillside Cottage is shown after the addition of the enclosed summer porches on the second and third floors and the tower. The pavilion is visible behind the cottage. The Lands at Hillside Farms plans to restore the Victorian-era Hillside Cottage to its former grandeur and transform it into a bed-and-breakfast. (Courtesy of the Lands at Hillside Farms.)

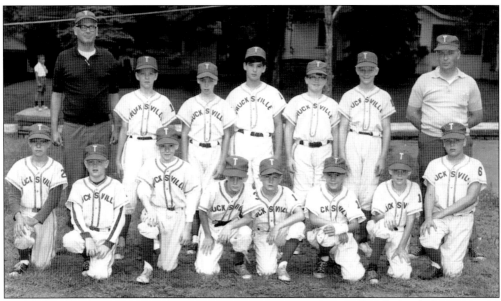

THE 1969 TRUCKSVILLE TIGERS LITTLE LEAGUE TEAM. The Trucksville Little League team was sponsored by the Howard Duke Isaacs Dealership and poses in front of the Trucksville Elementary School. Pictured from left to right are (first row) Jeff Prutzman, Bob Hislop, Rod Richards, Jeff Govin, Scott Parkhurst, Girard DeMarco, Don Fritzges, and Ray Dymond; (second row) coach Jim Duffy, Mark Engler, Kevin Rose, Tom Duffy, C. J. Siegel, Dave Fritzges, and coach Harold Rose. (Courtesy of Kevin Rose.)

Two
DALLAS

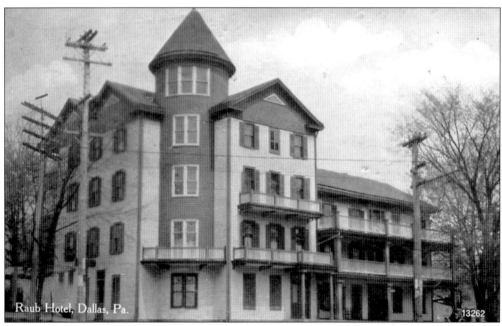

VIEW OF THE RAUB'S HOTEL, C. 1910. This postcard was taken from the Dallas corners across the intersection from the Wilkes-Barre Railway Corporation trolley station and the Lehigh Valley Railroad station. The Raub's Hotel was famous for its chicken dinners and had several permanent residents, including Dallas Bank president George R. Wright and Wilkes-Barre Railway Corporation general manager William S. Bell. The hotel was on the corner of Lake Street and Church Street. (Courtesy of Stephen B. Killian.)

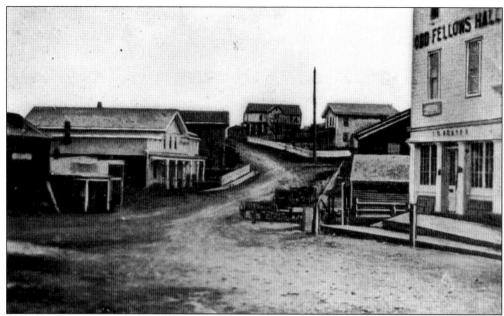

AN 1874 PAINTING OF THE DALLAS CORNERS. This view is from the intersection of the Kingston and Dallas Turnpike, Main Street, Lake Street, and Church Street. The Independent Order of Odd Fellows (IOOF) Oneida Lodge No. 371 met in the building on the right. It was destroyed by fire in 1893 and rebuilt in 1894. In 1939–1940, the building was moved over Toby's Creek to widen the road. (Courtesy of the Luzerne County Historical Society.)

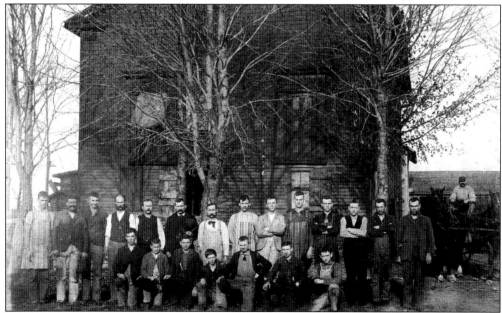

DALLAS BROOM FACTORY. In 1889, the Dallas Broom Factory opened on the corner of Lake Street and Center Hill Road. It was constructed by A. Goss for $960 in 1851 and became the Dallas Methodist Episcopal Church. It was purchased by the Religious Sisters of Mercy and was used by the College Misericordia home economics department. Renamed Rosary Hall, it houses the Women with Children Program at Misericordia University. (Courtesy of Carol Wall.)

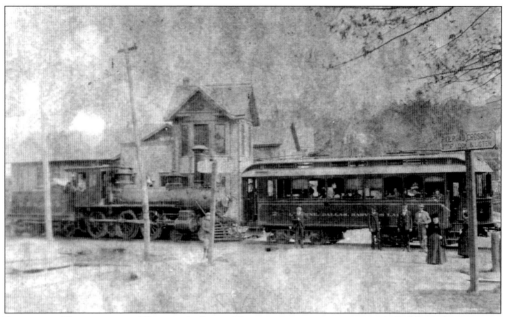

LUZERNE, DALLAS AND HARVEY'S LAKE RAILWAY, C. 1897–1898. A Baldwin locomotive pushing trolley No. 2 is coupled to another trolley at the Dallas corners. The trolleys were built by Jackson and Sharp and were delivered to the trolley company on October 8, 1896. This photograph was taken from the Raub's Hotel and shows the Dallas trolley station in the background. (Courtesy of the Edward S. Miller collection.)

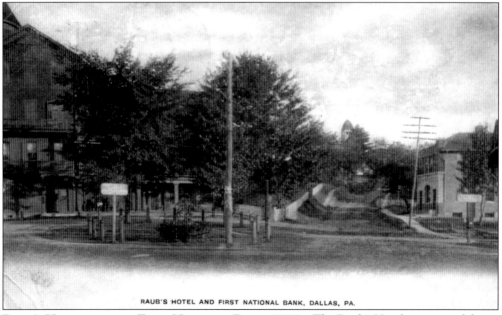

RAUB'S HOTEL AND THE FIRST NATIONAL BANK, 1900S. The Raub's Hotel was a wood-frame building built by Albert S. Orr in 1858 and was called the Luzerne House. This photograph was taken from the Dallas corners at the intersection of Church Street and Lake Street. The belfry of the Dallas Methodist Episcopal Church is visible in the background on Church Street. (Courtesy of the Misericordia University Archives.)

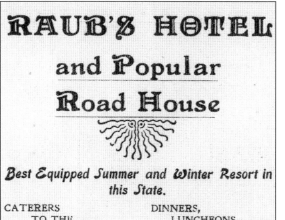

RAUB'S HOTEL ADVERTISEMENT, 1904. This advertisement was in response to competition from the Highland House in Dallas and the hotels at Harvey's Lake. At the height of the Raub's Hotel's popularity in the early 1900s, many organizations held social events and meetings there. The hotel was often the venue for events held by the George M. Dallas Lodge, No. 531, Free and Accepted Masons. Hotel proprietor Philip T. Raub was an active member of the lodge, and he served as secretary from 1875 to 1877, worshipful master in 1880, and treasurer from 1881 to 1900. The hotel had a three-story section facing the Dallas corners and a four-story addition with a five-story tower on Lake Street. Philip T. Raub sold the hotel to E. G. Stevens, who operated it until shortly before the hotel was razed in 1933. The hotel was in operation at the Dallas corners for nearly 75 years. (Courtesy of Howard and Lillian Gola.)

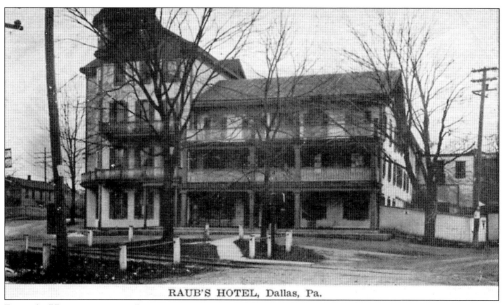

RAUB'S HOTEL AT THE INTERSECTION OF LAKE AND CHURCH STREETS, C. 1920. In 1875, Andrew Raub started managing the hotel, and he was a stockholder in the Dallas Broom Factory. In the 1880s, his son Philip T. Raub took over management of the Raub's Hotel. Andrew Raub and Philip T. Raub signed the petition incorporating Dallas Borough in 1879. (Courtesy of Stephen B. Killian.)

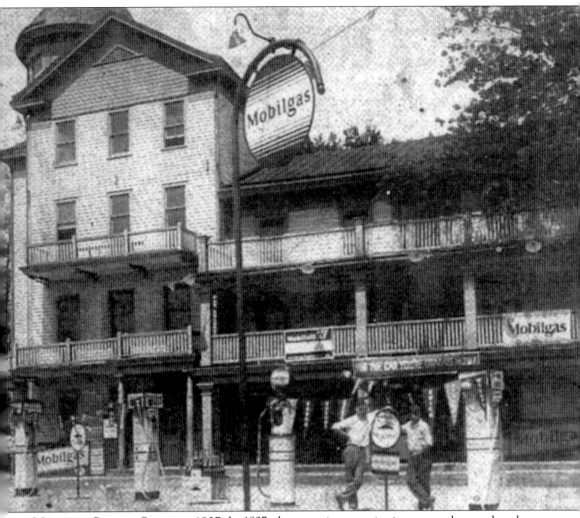

MOBILGAS SERVICE STATION, 1927. In 1927, three service organizations were chartered at the Raub's Hotel, including the Dr. Henry M. Laing Volunteer Fire Company, the Dallas Rotary Club on March 3, 1927, and the Mount Greenwood Kiwanis Club on July 20, 1927. By the 1920s, hotel business declined in Dallas. The Mobilgas service station was erected in front of the Raub's Hotel at the Dallas corners on the corner of Lake Street and Church Street. After the hotel closed, the service station expanded, and this photograph shows the Mobilgas advertisements on the hotel. This photograph was taken several years before the Raub's Hotel was razed in 1933. (Courtesy of the Misericordia University Archives.)

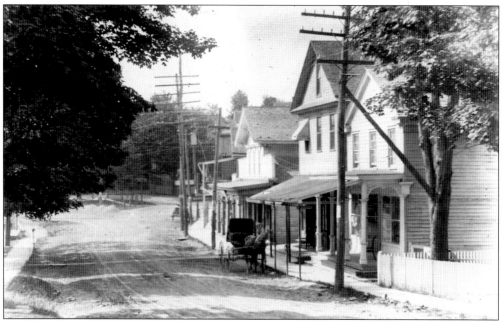

MAIN STREET, 1902. This view was taken in Dallas near the intersection of Huntsville Road looking toward the Dallas corners. The horse and buggy are close to the store owned by C. A. Frantz, who purchased the building after the death of store owner Ira D. Shaver. The Raub's Hotel is across the intersection from the Lehigh Valley Railroad station and the Dallas trolley station. (Courtesy of the Misericordia University Archives.)

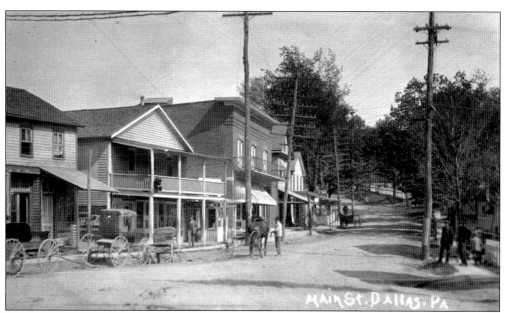

MAIN STREET LOOKING TOWARD THE INTERSECTION OF HUNTSVILLE ROAD, 1900s. On the left are the store owned by C. A. Frantz and the blacksmith shop and wagon workshop later purchased by Wesley T. Daddow. In 1909, C. A. Frantz replaced the wood-frame building with a two-story brick structure with apartments on the second floor. (Courtesy of Stephen B. Killian.)

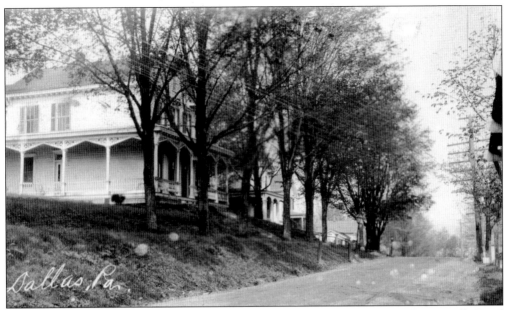

HOMES ON MAIN STREET, 1900S. These homes are near the intersection of Huntsville Road looking toward the Dallas corners. This photograph shows some of the large Victorian homes in Dallas. In 1945, the Back Mountain Memorial Library opened on Main Street before moving to its present location on Huntsville Road. Dr. John Carl Fleming (1884–1952) remodeled the house next to the library on Main Street. (Courtesy of Stephen B. Killian.)

MAIN STREET LOOKING TOWARD THE DALLAS CORNERS, C. 1900. This photograph was taken from the intersection of Huntsville Road and Main Street. Main Street was the main road in Dallas until the highway was built in the 1960s. Asa E. Lewis became principal of the Dallas High School in 1907. In 1911, he started the first Boy Scout troop in Dallas. (Courtesy of Stephen B. Killian.)

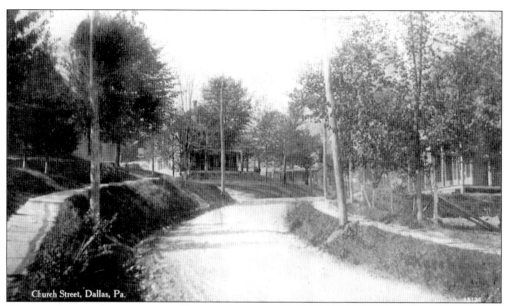

CHURCH STREET SEEN FROM THE DALLAS CORNERS, 1916. In 1875, the George M. Dallas Lodge, No. 531, Free and Accepted Masons, was chartered at the IOOF hall across the Dallas corners. Wood planks are seen here being used as sidewalks on both sides of Church Street. The Dallas Methodist Episcopal Church and the parsonage are on the left. (Courtesy of Stephen B. Killian.)

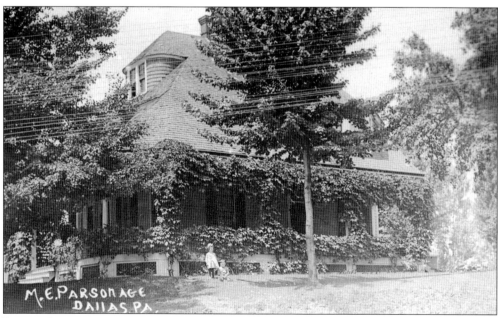

DALLAS METHODIST EPISCOPAL CHURCH PARSONAGE. The parsonage was built next to the Dallas Methodist Episcopal Church on Church Street in 1891. When the church purchased a new parsonage in 1964, the old parsonage was razed. After the War of 1812, the Methodists in Dallas were organized by Rev. George Peck at the house of Philip Kunkle. Before the first church was built, the congregation met in schools and homes. (Courtesy of Stephen B. Killian.)

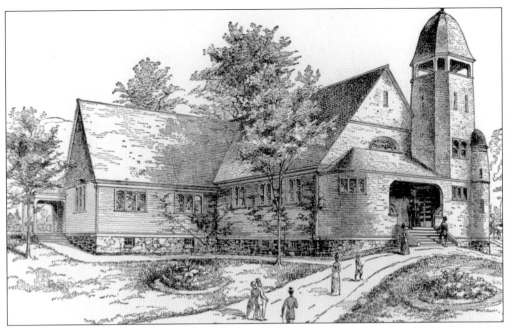

AN 1889 SKETCH OF THE DALLAS METHODIST EPISCOPAL CHURCH. The Dallas Methodist Episcopal Church was built on land bought from George W. Kirkendall and was dedicated by Bishop Cyrus David Foss on June 5, 1889. The church cost $9,000 to build. The original church on the corner of Center Hill Road and Lake Street was chartered on November 26, 1866, and was sold in 1889. (Courtesy of the Luzerne County Historical Society.)

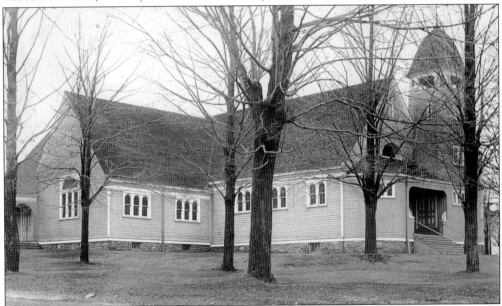

DALLAS METHODIST EPISCOPAL CHURCH, 1920S. This view was taken from Church Street. Methodist class meetings were held at the homes of Philip Kunkle, Richard Honeywell, and Christian Rice before the Methodist Church was chartered in Dallas. In the 1930s, a basement was built under the church on Church Street. By the 1950s, additional space was needed, and a new educational complex was built in 1958. (Courtesy of Stephen B. Killian.)

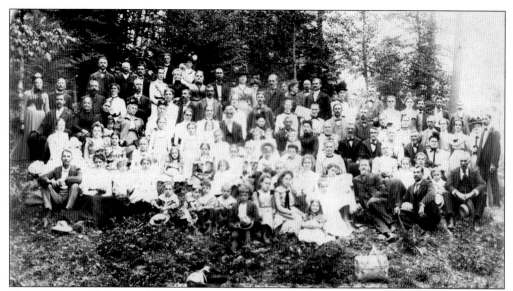

MAJOR FAMILY REUNION. The Major family reunion took place at Fern Brook Park in Dallas on September 8, 1900. This photograph includes William Major, Ruth Major, Martha Wilcox, Lena Major, Florence Major, Olive Major, George Neely, Rebecca Major Wilcox, Kathleen Major, Louise Major, David Major, Marshall Major, Isaac Major, Frank Major, Thomas Major, Alice Major, Emma Major, Dr. Arthur Major, Stella Major, Luther Major, Alice Campbell, Art Major, and Payne Major. (Courtesy of Judith Simms Dawe.)

FERN BROOK PARK, 1909. Like many early amusement parks, Fern Brook Park started out as a picnic grounds. John Graham, general manager of the Wyoming Valley Transit Corporation, sold the Fern Brook Park property in Dallas to the Wilkes-Barre and Northern Railroad for $47,400 in January 1898. A contest was held to name the park, and on the opening day on June 5, 1897, a $5 gold piece was awarded to Mary Hawley, who named it Fern Brook Park. (Courtesy of Howard and Lillian Gola.)

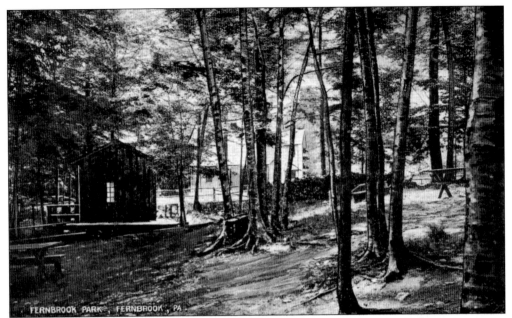

FERN BROOK PARK, SEPTEMBER 1, 1909. This was an invitation to the fifth reunion of the White and Carpenter families. The 17-acre park was next to the trolley tracks and offered cabins, camping, picnic grounds, rides, pavilions, and refreshment stands. Fern Brook Park brought many people to Dallas for social gatherings. The park competed with the attractions at Harvey's Lake. (Courtesy of Howard and Lillian Gola.)

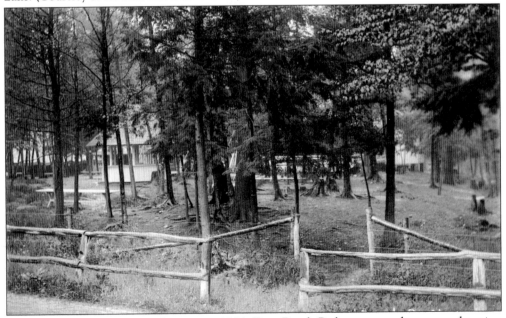

FERN BROOK PARK PICNIC GROUNDS, 1911. Fern Brook Park was near the present location of the Offset Paperback Manufacturers in Dallas. The trolley company owned the property the park was built on until 1948. In 1926, the Fern Brook Park Amusement Company leased the property. The remodeled park opened on May 29, 1926, with new rides, including the Wildcat roller coaster. (Courtesy of Howard and Lillian Gola.)

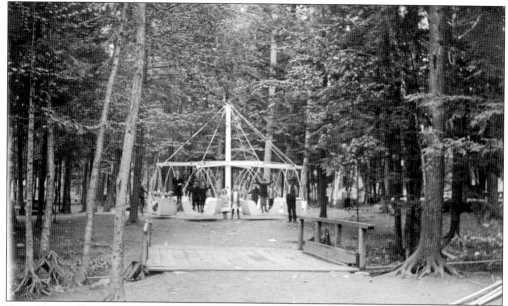

FERN BROOK PARK AMUSEMENT PARK RIDE, 1911. The Starlight Dance Hall opened in 1926, and it could accommodate 2,500 people. In the 1930s, the dance hall attracted bandleaders such as Eubie Blake (1883–1983), Cab Calloway (1907–1994), Duke Ellington (1899–1974), and Rudy Vallee (1901–1986). In 1936, the park was acquired by Fern Brook Park, Inc. Trolley service to Fern Brook Park was discontinued in 1939. (Courtesy of Howard and Lillian Gola.)

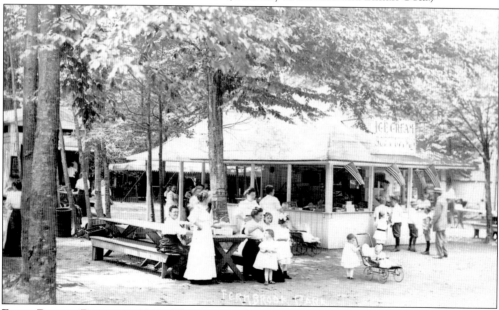

FERN BROOK PARK, C. 1913. This postcard shows the ice-cream stand and the growing popularity of Fern Brook Park. The park offered dancing, food and entertainment, rides, and a swimming pool. The 75-foot-high Wildcat roller coaster was designed by Herbert Paul Schmeck and built by the Philadelphia Toboggan Company in 1926. In 1946, the same architect and company designed and built the Comet roller coaster at Hershey Park. (Courtesy of Howard and Lillian Gola.)

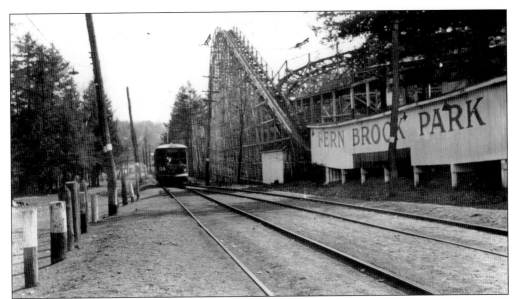

WILKES-BARRE RAILWAY CORPORATION TROLLEY NO. 322, FERN BROOK PARK, MARCH 25, 1938. This photograph was taken by Michael J. Lavelle and shows the trolley next to the Wildcat roller coaster near the passing track. Frank Sudol was killed on the roller coaster while attending a United Mine Workers picnic on July 18, 1929. The roller coaster and dance hall were demolished in the 1940s. (Courtesy of the Edward S. Miller collection.)

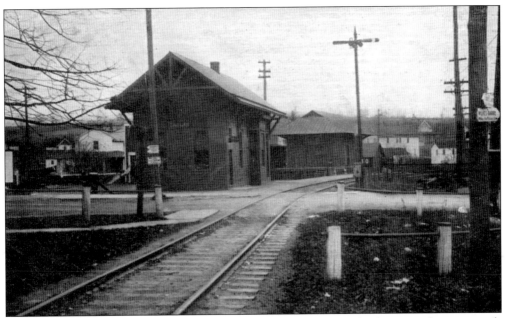

LEHIGH VALLEY RAILROAD STATION AND TRAIN DEPOT, 1920S. At this time, the main roads to Dallas were Main Street and Pioneer Avenue. This postcard shows the railroad tracks next to the road that became the Dallas Memorial Highway. The first steam engine reached Dallas on December 9, 1886. Passenger service was reduced to one train each way daily on December 19, 1928. (Courtesy of Stephen B. Killian.)

CHURCH STREET LOOKING TOWARD THE DALLAS CORNERS, 1908. This photograph shows the tower of the Raub's Hotel, at the intersection of Church Street and Lake Street, in the background. Many of the large summer houses in Dallas, built in the late 1890s and 1900s, became year-round residences as more people moved from the Wyoming Valley to the Back Mountain. (Courtesy of Howard and Lillian Gola.)

CHURCH STREET, 1940s. This view looks toward the Dallas corners and was taken close to the intersection with Center Hill Road. Before 1950, there were few houses on Church Street, and this photograph shows how rural Dallas was before new housing was constructed. Dr. James G. Laing (1831–1909) was an examining physician for draftees during the Civil War, and he lived on Lake Street in Dallas. (Courtesy of Pauline Shaver Roth.)

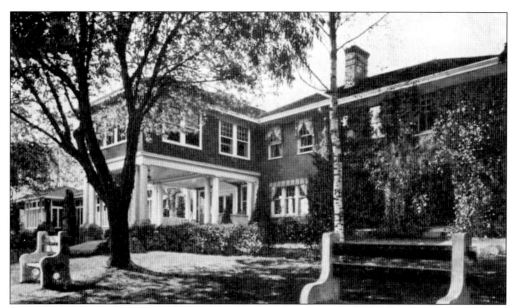

IREM TEMPLE COUNTRY CLUB, 1930S. In 1895, the Irem Shrine in Wilkes-Barre was chartered by the imperial council, and the first potentate, J. Ridgeway Wright, was installed on December 19, 1895. In the 1920s, the Derr estate, Watkins farm, and Honeywell farm in Dallas Township were purchased to build the country club. The club pavilion opened on May 23, 1925. (Courtesy of Stephen B. Killian.)

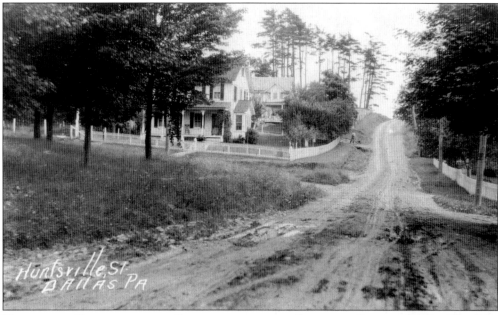

HUNTSVILLE ROAD NEAR THE INTERSECTION WITH FRANKLIN STREET, 1900S. The Rice cemetery, founded in the 1800s, is in the background on the right. The Norton farm, west of Huntsville Road, was surveyed by Charles H. Cooke for attorney John B. Reynolds in 1894. The survey opened Norton Avenue, Machell Avenue, Spring Street, King Street, and Terrace Street. (Courtesy of Stephen B. Killian.)

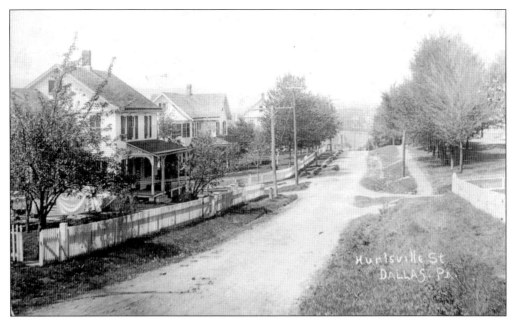

HUNTSVILLE ROAD LOOKING TOWARD THE INTERSECTION WITH MAIN STREET, 1900S. This photograph shows the houses on Huntsville Road across from the Dallas High School. The Back Mountain Memorial Library moved to the property across the road from where this photograph was taken. This was close to the intersection of Huntsville Road and Norton Avenue where the *Dallas Post* was published. (Courtesy of Stephen B. Killian.)

DALLAS HIGH SCHOOL, 1920S. The Dallas High School was on Huntsville Road near the present location of the Back Mountain Memorial Library. The first principal was John T. Fuller. When the school opened in 1878, it was the only high school west of Kingston. Dallas residents wanted to apply local taxes to the school, and this led to the petition incorporating Dallas Borough in 1879. (Courtesy of Stephen B. Killian.)

The Senior Class of

The Dallas High School

at Dallas, Penn'a

requests the honor of your presence at the

Commencement Exercises

at the Dallas M. E. Church

Wednesday Evening, May 17th

at Eight O'clock

nineteen hundred eleven

DALLAS HIGH SCHOOL COMMENCEMENT EXERCISES. The Dallas High School commencement exercises were held at the Dallas Methodist Episcopal Church on May 17, 1911. Graduates included Alice McGill Brace, Margaret May Bennett, Lillian Frances Smith, Sarah Ruth Mott, Charles Shaver Morris, Daniel Allen Waters, and William Elworth Welsh. The Dallas High School Association was incorporated on February 16, 1878. It purchased the property for the school and built the two-story building. The high school opened in October 1878, and it was equipped with heating and indoor plumbing. There were several one-room schoolhouses in Dallas before the high school was built. One of the most promising teachers was John J. Whitney. He enlisted during the Civil War, serving in the 53rd Pennsylvania Infantry Volunteer Regiment Company F, and rose to the rank of captain. He was killed in action, and the Dallas chapter of the Grand Army of the Republic was named for him. (Courtesy of Pauline Shaver Roth.)

Wesley T. Daddow General Blacksmithing Receipt. This receipt is for a horseshoeing done for William H. Harris from the Wesley T. Daddow general blacksmithing and wagon-making shop on Main Street in Dallas dated January 19, 1918. After World War I, Wesley T. Daddow moved his blacksmith shop and workshop to a new location in Dallas. He opened an automotive dealership and garage in the original location on Main Street close to the Dallas trolley station. He sold Ford and Dodge automobiles for several years. Another blacksmith in Dallas was Alex Johnston (1887–1974), who came from Scotland. He met William H. Conyngham and John N. Conyngham at a horse show in New York, and they persuaded him to relocate his business to the Back Mountain in 1910. His blacksmith shop was close to the present location of the U.S. post office on the Dallas Memorial Highway. (Courtesy of Howard and Lillian Gola.)

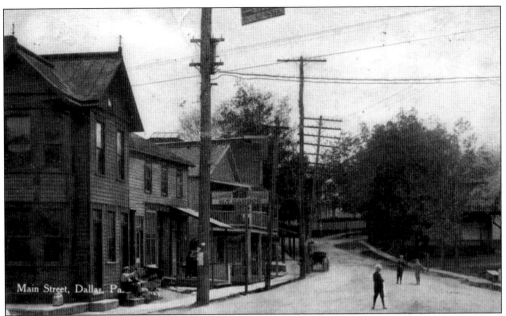

A 1900s VIEW OF THE DALLAS CORNERS FROM THE RAUB'S HOTEL. This postcard shows the Dallas trolley station and the blacksmith shop owned by Wesley T. Daddow next to the brick building owned by C. A. Frantz. In the background is the intersection of Main Street and Huntsville Road. Wesley T. Daddow purchased the blacksmith shop shortly before this photograph was taken. (Courtesy of Howard and Lillian Gola.)

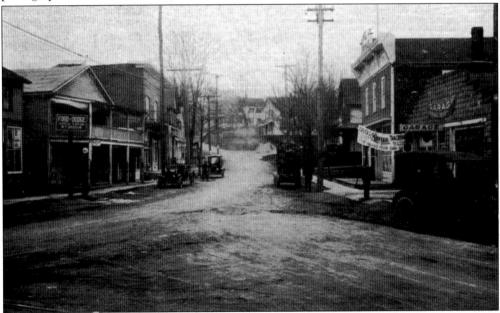

DALLAS CORNERS LOOKING TOWARD MAIN STREET AND HUNTSVILLE ROAD, C. 1920. On the left is the Ford and Dodge service station owned by Wesley T. Daddow across from the Koeler truck garage and tractor store. Paved roads and the increased number of automobiles signaled the decline of passenger train service and trolley service in the Back Mountain. (Courtesy of Stephen B. Killian.)

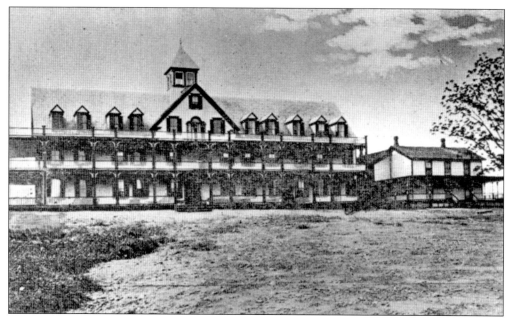

HIGHLAND HOUSE, 1900s. This three-story resort hotel was built before 1897 by W. G. Orr close to the present location of the Dallas Junior High School. The hotel was known for selling a specialty mineral water produced and bottled on the property by the Highland Water Company of Dallas. The hotel was destroyed by fire in about 1905. (Courtesy of the Luzerne County Historical Society.)

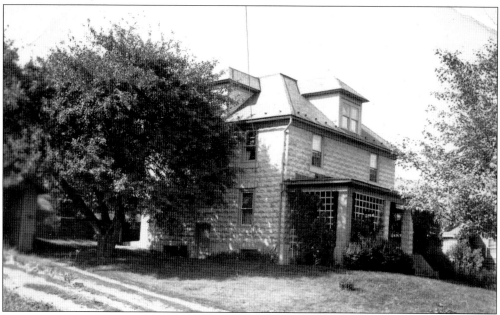

THE COOLBAUGH HOUSE ON LOWER DEMUNDS ROAD, 1920s. Johnson Van Buren Coolbaugh built the house by using poured concrete blocks. He was a trolley operator for the Wilkes-Barre Railway Corporation between Wilkes-Barre and Harvey's Lake. In 1918, Johnson Van Buren Coolbaugh became a past grand of the Toby's Creek Lodge of the IOOF in Trucksville. (Courtesy of Joan Coolbaugh Britt.)

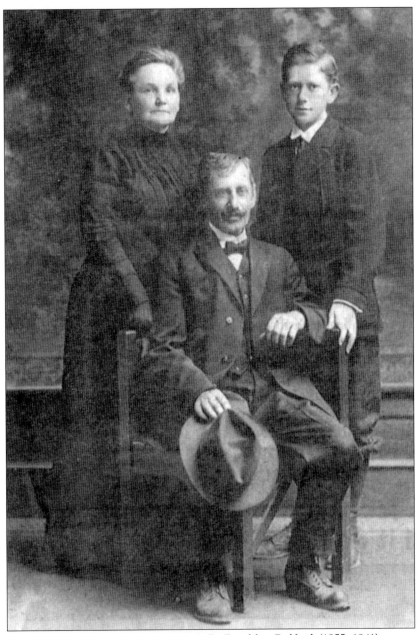

B. Franklin Bulford and Family, 1915. B. Franklin Bulford (1855–1941) poses with his wife, Ellen Duckworth Bulford, and their son, Arthur Bulford. B. Franklin Bulford was the son of John J. Bulford and Rachel Delong Bulford. He and his father signed the 1879 petition that incorporated Dallas Borough. B. Franklin Bulford and his wife raised their children on a farm on Overbrook Road in Dallas Township. Dallas Township was incorporated in 1817 and was named for Alexander James Dallas (1759–1817), who served as U.S. Treasury secretary under Pres. James Madison. The George M. Dallas Lodge, No. 531, Free and Accepted Masons, was named for the son of Alexander James Dallas. George M. Dallas (1792–1864) was a U.S. senator from Pennsylvania and was vice president under Pres. James K. Polk. (Courtesy of Joan Coolbaugh Britt.)

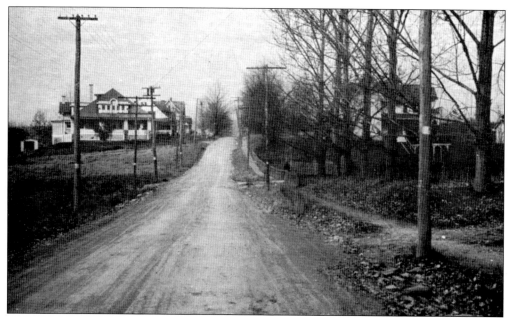

LAKE STREET IN DALLAS, 1920S. The house on the left in the background was built by Philip T. Raub, who managed the Raub's Hotel. In 2003, it was purchased by College Misericordia and became the Leadership House. The vacant property on the left was used to build the Commonwealth Telephone Company building. The property on the right became the law office of Bernard Walter. (Courtesy of Stephen B. Killian.)

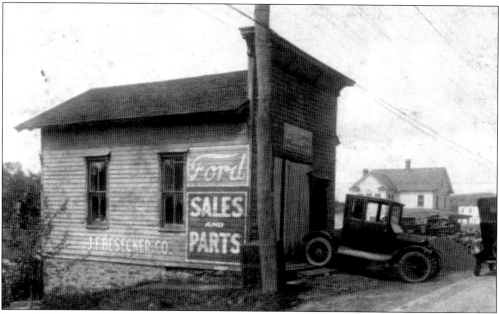

JAMES F. BESECKER'S FORD DEALERSHIP, LAKE STREET, 1923. James F. Besecker was the first secretary of the Dallas Rotary Club, chartered in 1927 at the Raub's Hotel. In 1929, the Himmler Theater opened next door. The dealership was purchased by Louis L. Richardson in 1938, and it was used as a showroom for the Richardson Dodge dealership. (Courtesy of the Misericordia University Archives.)

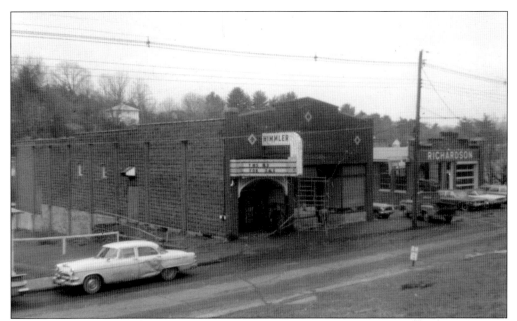

HIMMLER THEATER, 1967. The Himmler Theater was located next door to the Richardson Dodge dealership on Lake Street and was captured here by Dr. Harry Gallagher from his house across the street. Stanley Himmler opened the theater in 1929 with the movie *Hollywood Revue*. The building contained retail space, and tenants included the Dallas Water Company and a jewelry store. In 1955, the theater was sold to A. C. Devans, who operated it until 1960.

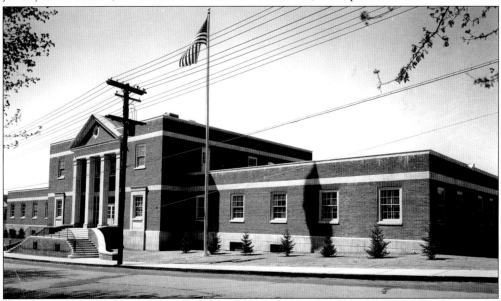

THE COMMONWEALTH TELEPHONE COMPANY BUILDING. The Commonwealth Telephone Company was consolidated and chartered on April 26, 1907. Ground was broken for the building on Lake Street on December 4, 1950, and it was designed by Lacy, Atherton and Davis. This photograph was taken after the building was completed by Sordoni Construction on October 18, 1955. Misericordia University purchased the property in 2008. (Courtesy of the Luzerne County Historical Society.)

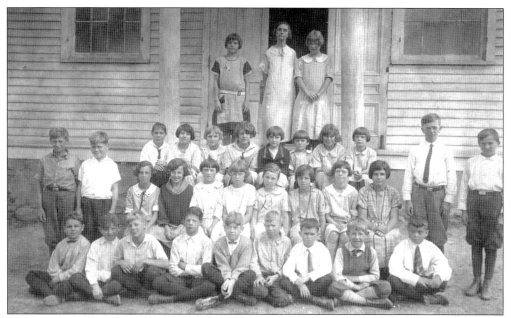

GOSS SCHOOL STUDENTS, C. 1923. This photograph includes Elizabeth Frantz Billings in the second row and was taken from the intersection of Center Hill Road and Church Street at the present location of the Dr. Henry M. Laing Volunteer Fire Company. Dr. Henry M. Laing (1862–1923) lived in Dallas and was a selective service board examining physician during World War I. (Courtesy of Albert Billings.)

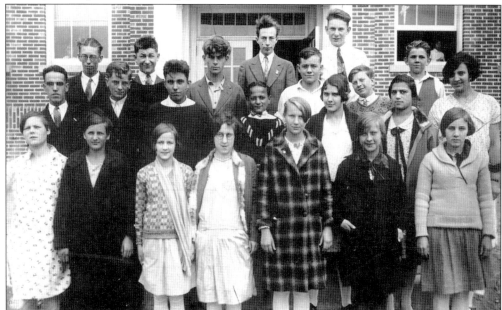

DALLAS TOWNSHIP HIGH SCHOOL STUDENTS, 1929. This photograph was taken in front of the brick school building on Church Street in Dallas. The first row includes Jean Stark Johnson and Elizabeth Frantz Billings. The third row includes Sheldon Frantz and Red Carey. The Dallas Township High School was built, near the Goss School, to accommodate the growing population in Dallas. (Courtesy of Albert Billings.)

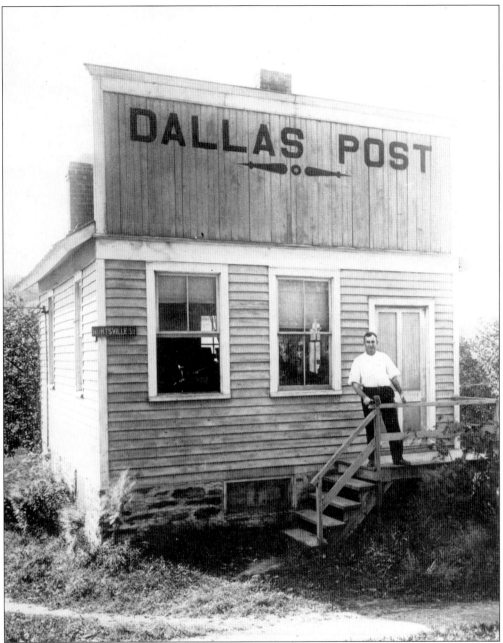

DALLAS POST BUILDING, 1920s. The building where the *Dallas Post* was published is located on the corner of Huntsville Road and Norton Avenue across from the present location of the Back Mountain Memorial Library. In 1889, the *Dallas Post* was started by A. A. Holbrook. W. H. Capwell became editor of the newspaper in 1895. This building was purchased by Paul Shaver, who built a house in front of the property facing Norton Avenue in the 1930s. The Grand Army of the Republic (GAR), Captain John J. Whitney Post No. 339, met in a building owned by Capt. Jacob Rice on Huntsville Road. GAR membership declined after World War I. The last surviving Civil War veteran from Dallas was Peter Culp, who was a corporal in the 53rd Pennsylvania Volunteer Infantry Regiment Company F. (Courtesy of Pauline Shaver Roth.)

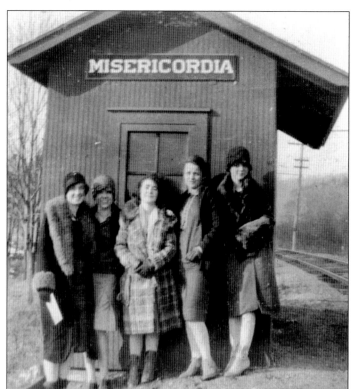

COLLEGE MISERICORDIA STUDENTS, 1925. These students are pictured standing in front of the trolley station in Dallas. Students could take the trolley to Wilkes-Barre and Harvey's Lake. Many students, including Freda Thalenfield Popky and Helen Rita Gildea, who both graduated in 1928, commuted from the Wyoming Valley to College Misericordia by taking the trolley. The trolley station was close to the college entrance on Lake Street. (Courtesy of the Misericordia University Archives.)

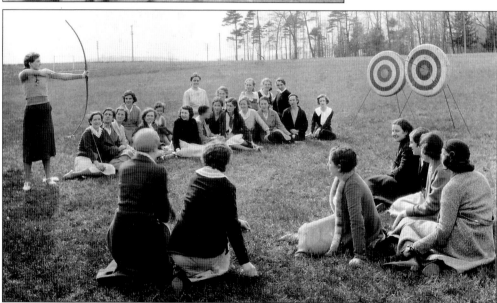

STUDENTS PRACTICING ARCHERY ON THE GROUNDS OF COLLEGE MISERICORDIA, 1930S. The students are practicing near the present location of the Anderson Sports and Health Center. In 1930, College Misericordia hired its first athletic coach, Agnes M. Berry, who planned a physical education curriculum and created athletic teams, including basketball, field hockey, tennis, and volleyball. In the 1940s, College Misericordia had competitive basketball and field hockey teams. (Courtesy of the Misericordia University Archives.)

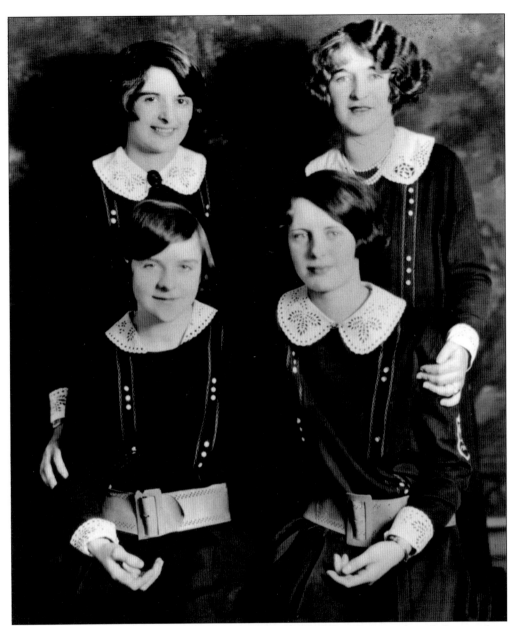

THE 1924–1925 COLLEGE MISERICORDIA DEBATE TEAM. This photograph includes members of the class of 1928. From left to right are (first row) Helen Rita Gildea and Mary S. Coleman; (second row) Angela Carey and Margaret Allen. After graduating, Helen Rita Gildea (1907–1997) joined the Religious Sisters of Mercy in 1930 and became Sr. Marianna Gildea, RSM. Thirty-seven students started their collegiate education when College Misericordia opened on September 24, 1924. College Misericordia was founded by the Religious Sisters of Mercy and was the first four-year college in Luzerne County. Mother Catharine McGann, RSM, served as the first academic dean from 1924 to 1937. New buildings and construction during this time included St. Joseph's Cottage, McAuley Hall, additions to the Administration Building, and the entrance arch. Between 1927 and 1937, the number of students graduating from College Misericordia increased from 5 to 55. (Courtesy of the Misericordia University Archives.)

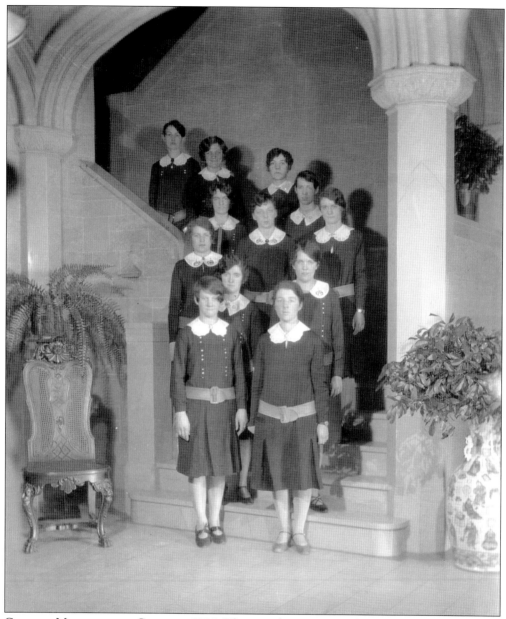

COLLEGE MISERICORDIA CLASS OF 1929. These students pose on the marble steps in the foyer of the Administration Building. The cornerstone of the four-story building was laid in 1922. The Administration Building was the only building on campus when College Misericordia opened in 1924. The building included the chapel, classrooms, dining facilities, housing for students and the Religious Sisters of Mercy, and faculty and administrative offices. This photograph includes Agnes Conway Williamson, Marjorie McCaffrey Dickinson, Ethel Hogan, Catherine Broderick, Mary Klein Curray, Elizabeth Price Norbert, Mary McBrearty, Regina Hurley Linton, Margaret Kane, Jule Prisbeck, Emily Hauser, and Jeanette Walsh Conyngham. Students wore school uniforms in the 1920s and 1930s. In 2002, the Administration Building was rededicated as Mercy Hall in honor of the college's founders, the Religious Sisters of Mercy. (Courtesy of the Misericordia University Archives.)

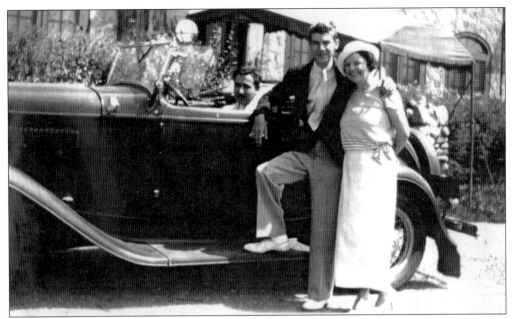

HAROLD F. BLEWITT AND FAMILY, 1927. Harold F. Blewitt is pictured with his wife, Elizabeth Huntzinger Blewitt, and her son, Joseph C. Huntzinger, in front of the Castle Inn. In 1925, the Blewitt family purchased the property. Construction of the Castle Inn started in 1926 and was completed in 1927. This photograph was taken near the main road between Dallas and Harvey's Lake that became the Dallas Memorial Highway. During World War II, both Harold F. Blewitt and his stepson Joseph C. Huntzinger went into the service. Joseph C. Huntzinger enlisted in the U.S. Army Air Corps and was sent to glider pilot training school. (Courtesy of Omar and Lori Hallsson.)

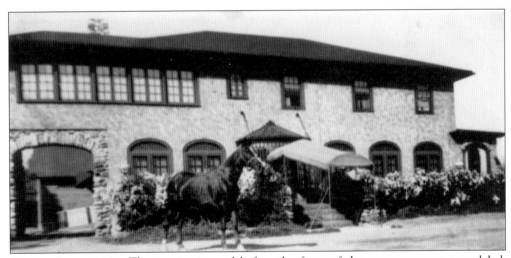

CASTLE INN, 1930S. The inn is pictured before the front of the restaurant was remodeled. After Prohibition, the bar was added to the restaurant in 1937. Many service organizations meet at the Castle Inn, including the Dallas Rotary Club, IOOF, Kiwanis Club, and Lions Club. International chef Omar Hallsson, a native of Iceland, has owned the Castle Inn since 1992. (Courtesy of Omar and Lori Hallsson.)

WILLIAM K. GOSS IN HIS WORKSHOP ON CHURCH STREET, 1900S. William K. Goss and his sister Mary Goss lived on the family farm purchased by A. Goss in 1840. A. Goss operated a store close to the intersection of Center Hill Road and Kunkle Road, known as Goss corners. William K. Goss sold tools from his workshop on Church Street. In the 1870s, he built the house at 251 Church Street across the road from his workshop. William K. Goss walked the nine miles between Dallas and Wilkes-Barre to conduct business. The Goss School that stood on the corner of Church Street and Center Hill Road, at the present location of the Dr. Henry M. Laing Volunteer Fire Company, and the Goss Manor housing developments were named for the Goss family. (Courtesy of Pauline Shaver Roth.)

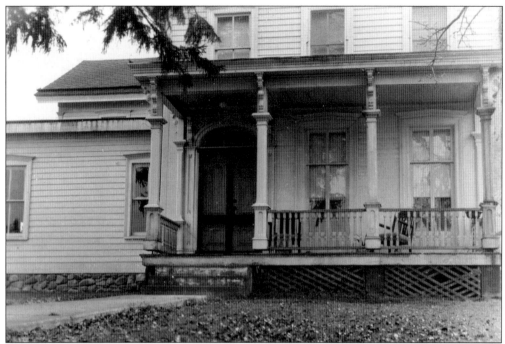

No. 251 Church Street, 1939. William K. Goss built this house in Dallas in the 1870s. In about 1900, Goss owned a barn and workshop across Church Street from the property. In the 1930s, Oscar Roth and his family moved into the house. He and his son Edwin Roth owned the Roth jewelry store in Dallas. (Courtesy of William and Barbara Wentz.)

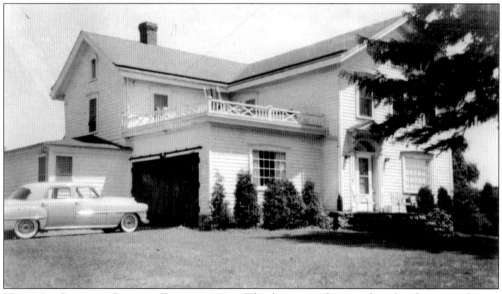

No. 251 Church Street, Early 1960s. The house is shown after the front porch was removed, and the new additions include an attached garage and study. William Wentz purchased the property from the estate of Oscar Roth in 1962, and his family moved into the house in 1963. William Wentz and his brother Robert Wentz owned the Hilsher Paper Box Company in Kingston. (Courtesy of William and Barbara Wentz.)

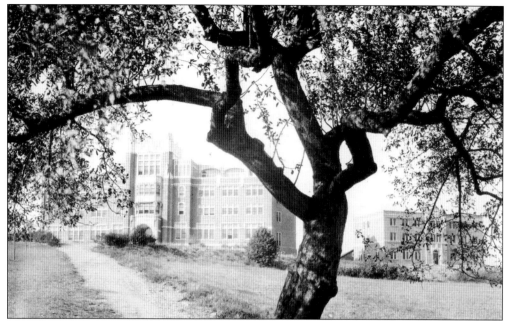

COLLEGE MISERICORDIA 1928 YEARBOOK PHOTOGRAPH. This photograph, taken between campus and Lake Street, shows the Administration Building before the east and west wings were added and McAuley Hall on the right. McAuley Hall was completed in 1928 and served as a residence hall. This photograph shows part of the roofline of St. Joseph's Cottage between the Administration Building and McAuley Hall. (Courtesy of the Misericordia University Archives.)

HUNTSVILLE ROAD AREA, 1932. Shown is the Raub's Hotel at the Dallas corners before it was razed and College Misericordia on the hill. This is one of the earliest photographs of the Tudor Gothic entrance arch at College Misericordia on Lake Street, and it shows the Administration Building and McAuley Hall. The entrance arch was completed in 1932. (Courtesy of the Misericordia University Archives.)

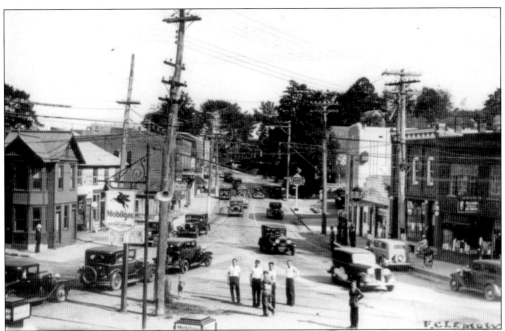

VIEW OF DALLAS CORNERS FROM THE MOBILGAS SERVICE STATION BY FRED CLEMOW, 1933. This service station was in front of the Raub's Hotel at the intersection of Church Street and Lake Street. The photograph shows three service stations and automotive dealerships at the Dallas corners. The Wilkes-Barre Railway Corporation trolley station is on the left across from the Lehigh Valley Railroad station. (Courtesy of the Misericordia University Archives.)

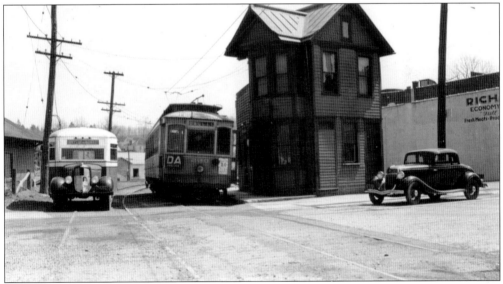

WILKES-BARRE RAILWAY CORPORATION TROLLEY NO. 280 AND THE HARVEY'S LAKE BUS. These vehicles are pictured between the trolley station and the Lehigh Valley Railroad station. The photograph was taken by Edward S. Miller from the Dallas corners on April 21, 1939. A fire destroyed 13 trolleys stored in Dallas on October 24, 1934. The final day of trolley service to Dallas was on April 30, 1939. (Courtesy of the Edward S. Miller collection.)

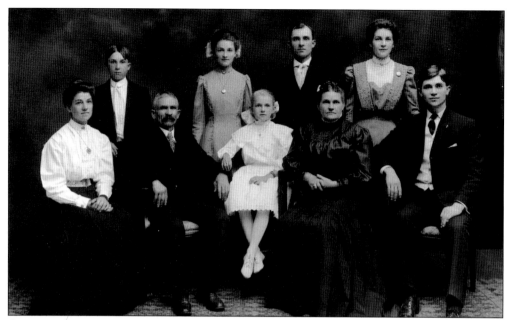

GEORGE ESTOCK AND SUSANNA WILHELMINA ESTOCK FAMILY, WILKES-BARRE, 1908. The Estock family came from Austria in 1882 and settled in Hazleton. Pictured from left to right are (first row) Mary Estock, George Estock, Helen Estock, Susanna Wilhelmina Estock, and George Estock Jr.; (second row) Michael Estock, Susan Estock, John Gustave Estock, and Anna Estock. John Gustave Estock moved his family to Dallas Township in 1925. (Courtesy of Wilhelmina Estock.)

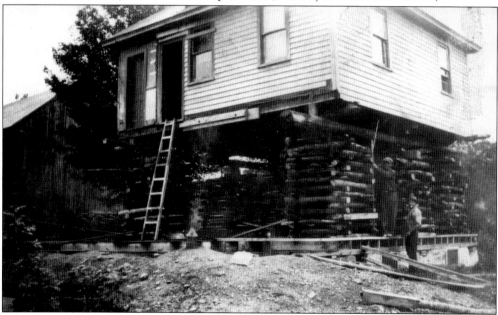

SUMMER COTTAGE ON OVERBROOK ROAD, 1925. This cottage in Dallas Township was purchased by John Gustave Estock and his wife, Anna Nytek Estock, in 1919. They were married in Wilkes-Barre on July 31, 1907. The house was originally one story, and carpenters raised it using logs to dig a basement and construct a new first floor. The family lived there during the summers before it was remodeled. (Courtesy of Wilhelmina Estock.)

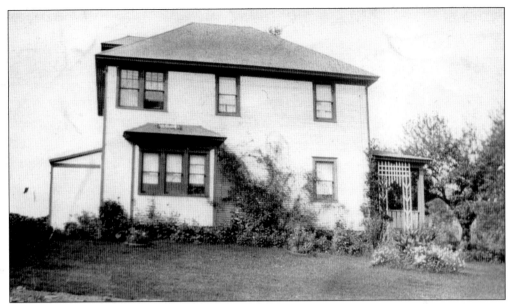

ESTOCK FAMILY HOUSE ON OVERBROOK ROAD, 1930s. The house in Dallas Township is pictured after the basement and new first floor were added. In 1925, the family moved from Wilkes-Barre to Dallas after the house was remodeled. John Gustave Estock and his wife, Anna Nytek Estock, raised their five children, Edward, Elizabeth, John, Irene, and Wilhelmina, in Dallas. Their children graduated from Dallas Township High School. (Courtesy of Wilhelmina Estock.)

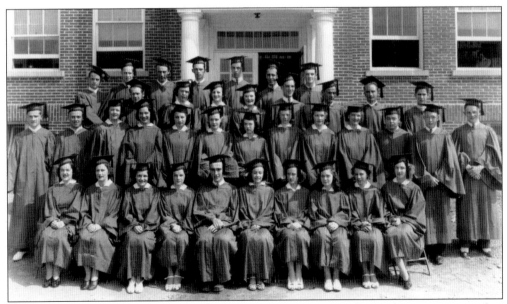

DALLAS TOWNSHIP HIGH SCHOOL 1940 GRADUATING CLASS. The graduates are pictured in front of the brick school building on Church Street. The photograph includes Wilhelmina Estock in the front row on the far right, class president Donald McDermott, Jeanne Miller, Robert O'Boyle, Ida Schoonover, and William Snyder. The Dallas Township High School consolidated with the high school in Dallas Borough, and a new high school was constructed on Conyngham Avenue. (Courtesy of Wilhelmina Estock.)

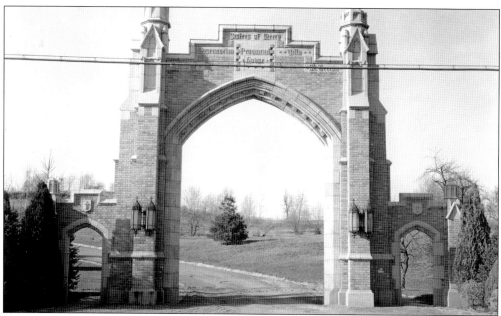

ENTRANCE ARCH ON LAKE STREET AT COLLEGE MISERICORDIA, 1933. The Tudor Gothic brick structure was constructed when the east and west wings of the Administration Building were added in 1930–1932. The entrance arch was designed by architect Francis Ferdinand Durang (1884–1966), who designed the Administration Building in 1922. Mercy Center was built behind the entrance arch in the 1960s. (Courtesy of the Misericordia University Archives.)

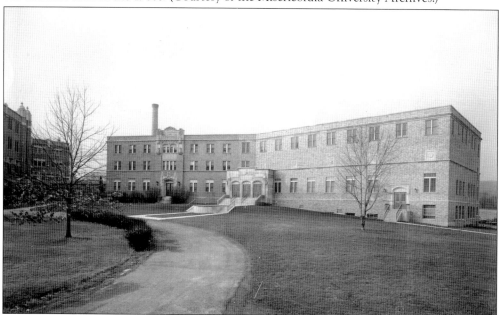

MCAULEY HALL AND WALSH HALL, COLLEGE MISERICORDIA, 1950s. Walsh Hall was dedicated in 1952 and housed the auditorium, gymnasium, and senior residence hall. It was named for Mother Theresa Walsh, RSM. She died as a result of the fire that destroyed St. Mary's Convent on Washington Street in Wilkes-Barre, the home of the Religious Sisters of Mercy, on March 21, 1920. (Courtesy of the Misericordia University Archives.)

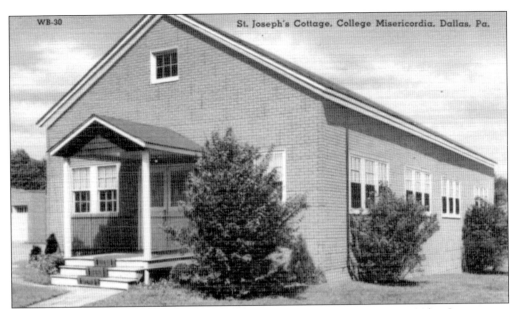

ST. JOSEPH'S COTTAGE AT COLLEGE MISERICORDIA, 1940S. In 1927, St. Joseph's Cottage was built as a gymnasium. Following World War II, College Misericordia experienced unprecedented student enrollment, and St. Joseph's Cottage was converted into a residence hall. A new gymnasium was built under the Walsh Hall auditorium. In 1980, the gymnasium in Walsh Hall was named the McGinty Gym in honor of Sr. Eloise McGinty, RSM. (Courtesy of the Misericordia University Archives.)

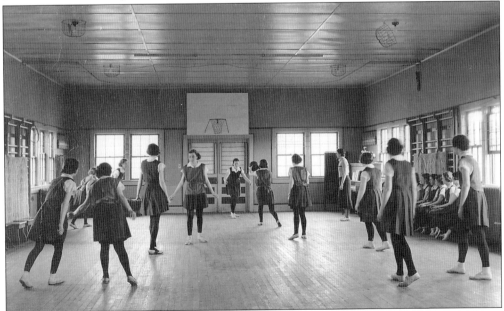

COLLEGE MISERICORDIA STUDENTS PLAYING BASKETBALL IN ST. JOSEPH'S COTTAGE, 1930S. Note the caged lighting fixtures and the 16-foot ceilings. St. Joseph's Cottage was behind the Administration Building and McAuley Hall near the present location of Sandy and Marlene Insalaco Hall. St. Joseph's Cottage served as the gymnasium for nearly two decades and was used for team practice and sporting events. (Courtesy of the Misericordia University Archives.)

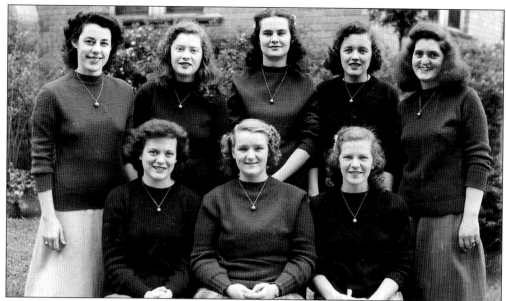

COLLEGE MISERICORDIA 1946–1947 BASKETBALL TEAM'S GRADUATING SENIORS. Pictured from left to right are (first row) Kathryn Hennessy, June Kistler, and Ave Maria Turnball; (second row) Doris Janton, Genevieve Grill, Mary Elizabeth Rienzo, Mary Cassidy, and Kathryn Masterson. This photograph was taken in front of McAuley Hall after an award ceremony for the team's winning season. Each player received a gold necklace with a basketball pendant. (Courtesy of Elizabeth Rienzo Noll.)

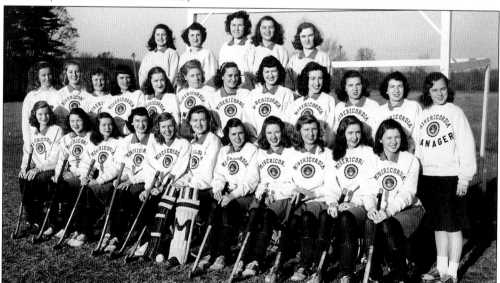

COLLEGE MISERICORDIA FIELD HOCKEY TEAM, 1947. This photograph includes Mary Gallagher, Doris Cooney, Regina Mack, Anne Rose, Aileen Fritzges, Lucy Matthews, Kathleen Kiernan, Mary McGonegal, Edna Hodges, Miriam Terry, Carmel Cavanaugh, Marie Morris, Kathy Dougherty, Margaret Paye, Joan Matthews, Martha Williamson, Rosemary Heck, Vera Troback, Marie Thomas, Eileen Treanor, Mary Caravati, Gloria Piccone, Gertrude Cochrane, Mary Beatty, Lois Mester, Joan Madden, Dorothy Cadan, and Nancy Lewis. (Courtesy of Maria Thomas Sowa.)

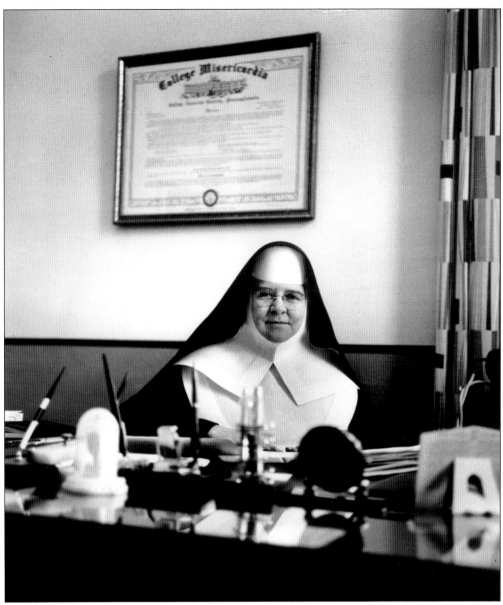

SR. MARIANNA GILDEA, RSM. Sr. Marianna Gildea served as academic dean of College Misericordia from 1957 to 1967. In the background is the 1927 charter granting the college the right to confer undergraduate degrees. A native of Luzerne, she was valedictorian of her class at College Misericordia. After joining the Religious Sisters of Mercy, Sr. Marianna Gildea, RSM, earned her doctorate from Fordham University and returned to teach languages at College Misericordia. From 1924 to 1957, the academic dean was the chief administrator at College Misericordia. In 1957, Sr. Celestine McHale, RSM, became president of College Misericordia. She and Sr. Marianna Gildea, RSM, graduated from College Misericordia in 1928. Under their leadership, new construction included Bishop Hafey Memorial Science Hall, Merrick Hall, and Alumnae Hall. McHale Hall and Gildea Hall were named in their honor. (Courtesy of the Misericordia University Archives.)

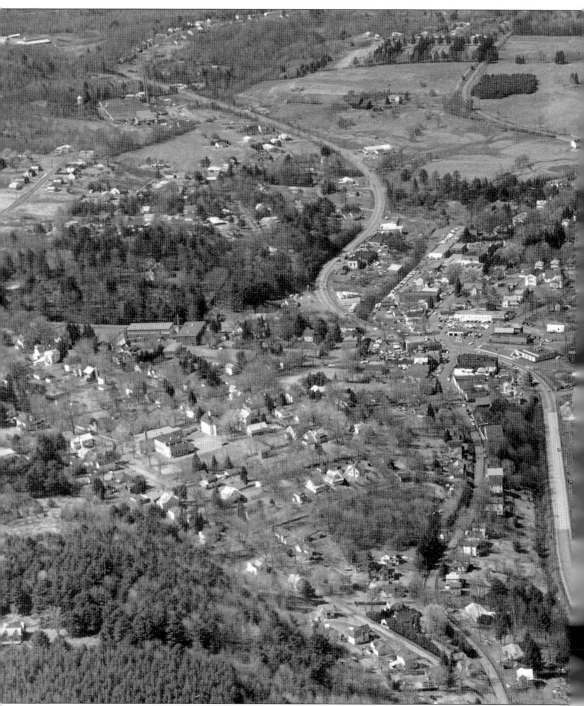

AERIAL VIEW OF THE DALLAS MEMORIAL HIGHWAY, 1960s. This photograph shows College Misericordia in the top center. This photograph was taken after the 1962–1963 construction of Merrick Hall and Alumnae Hall at College Misericordia. This photograph shows the Dallas Memorial Highway after the removal of the Lehigh Valley Railroad tracks, the Dallas station, and the train depot. This photograph was taken close to the intersection near the present location

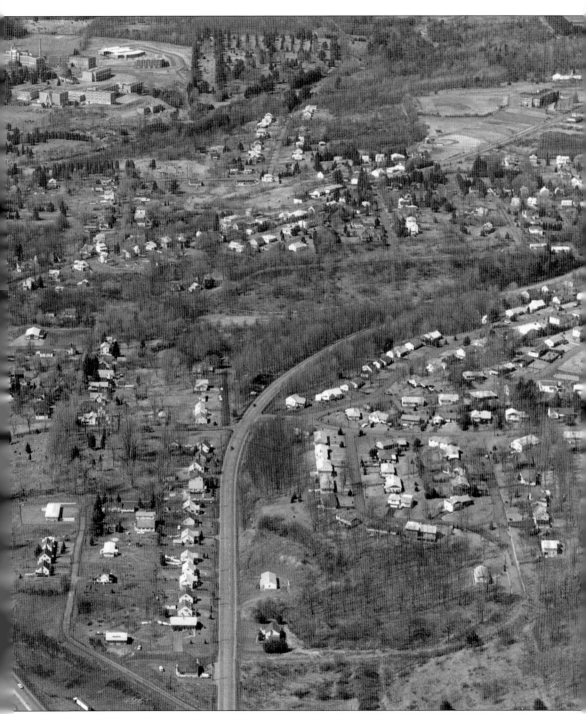

of the Friendly's restaurant in Dallas of State Route 415 to Harvey's Lake and State Route 309 to Tunkhannock. The suburban development of Dallas was evident before the 1972 flood caused by Hurricane Agnes. Population in the Back Mountain grew considerably after the flood's devastation of the Wyoming Valley. Many summer cottages in Dallas and at Harvey's Lake were converted into permanent residences. (Courtesy of the Luzerne County Historical Society.)

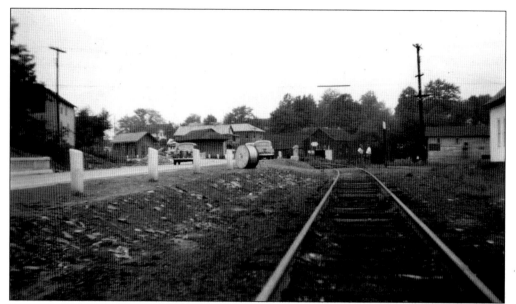

ROAD INTO DALLAS, 1940s. Coming into town, the Lehigh Valley Railroad station and train depot can be seen in the background. This photograph was taken from the railroad tracks looking toward the Dallas corners after passenger train service and trolley service between Dallas and Harvey's Lake were discontinued. The road on the left became the Dallas Memorial Highway after the railroad tracks were removed. (Courtesy of the Luzerne County Historical Society.)

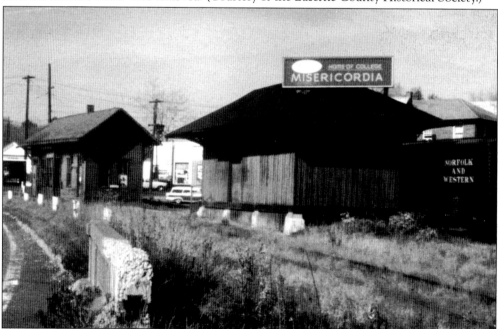

LEHIGH VALLEY RAILROAD STATION AND TRAIN DEPOT, C. 1960. This photograph was taken from the road looking toward the Dallas corners after the railroad discontinued service. Freight service between Luzerne and Noxen was discontinued on December 22, 1963. This photograph was taken before the railroad tracks were removed and the Dallas station and train depot were razed. (Courtesy of the Misericordia University Archives.)

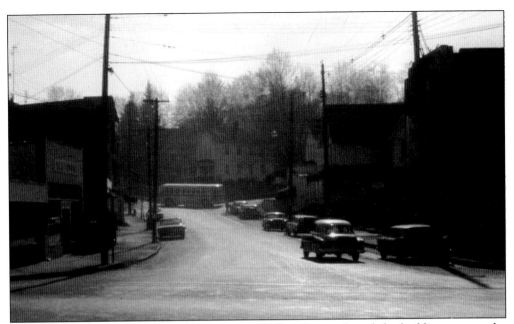

DALLAS CORNERS, C. 1960. In 1963, Dominic P. Fino Sr. purchased the building next to the Miners National Bank from Frank Kuehn, whose father, Gustave A. A. Kuehn, had owned a drugstore on the first floor of the building since the 1920s. The building was constructed by the IOOF Oneida Lodge No. 371. The drugstore was renamed Fino's Pharmacy. (Courtesy of the Misericordia University Archives.)

THE DALLAS ROTARY CLUB STUDENT EXCHANGE PROGRAM. The Rotary Club announced the student exchange program recipients on July 13, 1961. Pictured from left to right are (first row) Annabelle Ambrose, Marilyn Eck, Mary Alice Knecht, Dah Rodsand, and Lynne Jordan; (second row) Red Ambrose, Mert Jones, James Knecht, Paul Gross, James Alexander, and Richard Demmy. Dallas Rotarian Lesley Jordan, past district governor of Rotary International District 7410, founded the Rotary International Student Exchange Program. (Courtesy of the Dallas Rotary Club.)

CONGRESSMAN DANIEL J. FLOOD. Congressman Daniel J. Flood (1903–1994) is pictured at the Back Mountain Memorial Library auction in Dallas. He represented Pennsylvania's 11th District in the U.S. House of Representatives from 1945 to 1947, 1949 to 1953, and 1955 to 1980. He was on the House Appropriations Committee, developed the Luzerne County interstate system, and sponsored the 1961 Area Redevelopment Act and the 1969 Federal Coal Mine Health and Safety Act. (Courtesy of the Back Mountain Memorial Library.)

U.S. ARMY HELICOPTER LANDING AT COLLEGE MISERICORDIA, JUNE 1972. During the 1972 flood caused by Hurricane Agnes, College Misericordia served as an evacuation center for the Wyoming Valley. More than 1,500 people were evacuated to the campus. The Nesbitt Hospital on Wyoming Avenue in Kingston transferred patients to College Misericordia, and emergency medical services were moved to the basement of Alumnae Hall. (Courtesy of the Misericordia University Archives.)

Three

LEHMAN TOWNSHIP

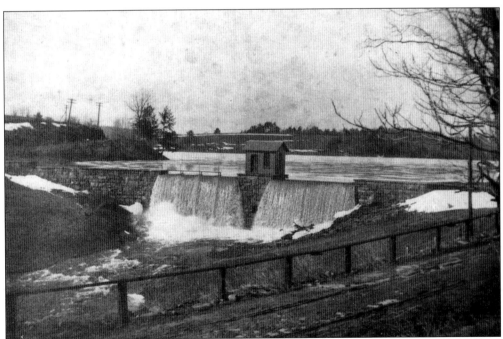

HUNTSVILLE RESERVOIR DAM, 1900S. The Huntsville Reservoir dam is located on Huntsville Road near the five corners. Farmland and a cranberry marsh in Dallas Township, Jackson Township, and Lehman Township were flooded to create the 389-acre reservoir. Construction was started in 1890 by the Wilkes-Barre Water Company and completed in 1892. Water flows from the reservoir to the Wilkes-Barre Water Company filter plant on Hillside Road. (Courtesy of the Luzerne County Historical Society.)

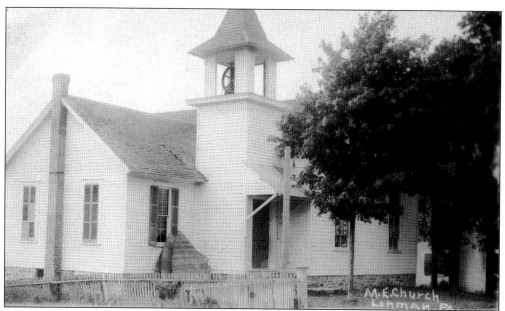

LEHMAN METHODIST EPISCOPAL CHURCH ON MOUNTAIN VIEW DRIVE. The Lehman Methodist Episcopal Church was built on property donated by William Henry Major and was dedicated on November 25, 1856. The church was enlarged in 1893. The church merged with the Idetown United Methodist Church to become the Lehman-Idetown United Methodist Church in 2004. One of the early class leaders of the Idetown Methodist Episcopal Church was Elijah Ide (1781–1860). (Courtesy of the FCP collection.)

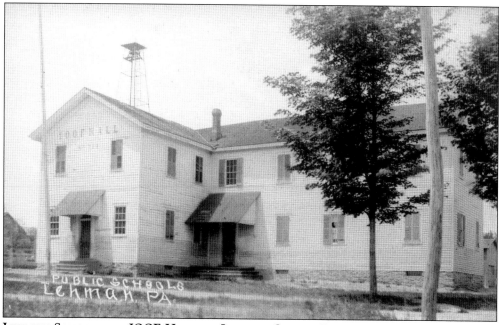

LEHMAN SCHOOL AND IOOF HALL ON LEHMAN OUTLET ROAD. In 1836, the first Lehman schoolhouse was built by Daniel Whiteman and Oliver Ide. Early schoolteachers were Ellen Pugh and Maria Fuller Ketcham. The IOOF Osage Lodge No. 712 met at the school, and the IOOF hall moved to the corner of Mill Street and Market Street. (Courtesy of the FCP collection.)

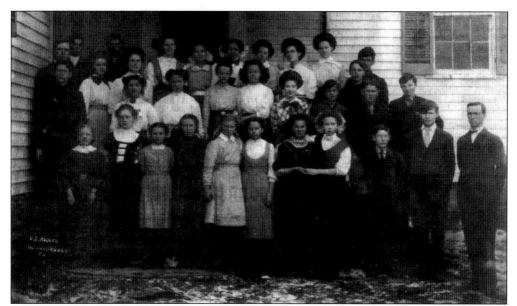

LEHMAN SCHOOL STUDENTS, 1910. This photograph includes Clifford Ide, Ray Crispell, Ruth Major, Goldie Ide, Edith Sutton, Irene Pollock, Herbert Perrego, Raymond Searfoss, Louise Major, Reed Whitesell, James Brace, Sarah Crispell, Alice Elston, Grace Nulton, Donald Frantz, James Park, Ralph Mekeel, Marian Ide, Beatrice Mekeel, Ruth Evans, Florence Searfoss, Ella Sutliff, Bertha Johnson, Luke Brown, Clarence Elston, Leroy Ruggles, and teacher Harry Wildrick. (Courtesy of Joan Coolbaugh Britt.)

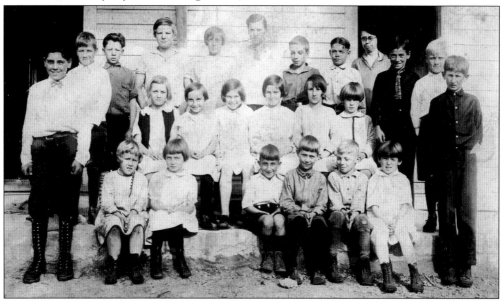

FIRST- THROUGH SIXTH-GRADE STUDENTS, MEEKER SCHOOL, 1927. The Meeker School was located on the corner of Meeker Outlet Road and Meeker-Lehman Road. This photograph includes Raymond King, Elma Scovell, Lawrence Wolfe, Marian Wentz Harvey, John Scovell, Robert Disque, Joseph Trojan, Philip Disque, teacher Beatrice Cornell, Leona Trojan, Martha Pahler, Pearl Garnet, Louise Garnet, Barbara Disque, Dorothy King, Arlene Josuweit, Warren Scovell, Charles Smith, James Oliver, and Marian Disque. (Courtesy of Dorothy King Wadas.)

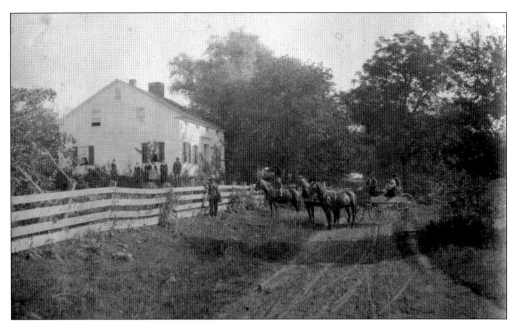

MEKEEL HOUSE, 1890S. The Mekeel House, built before 1860, was located on the corner of Old Route 115 and Mountain View Drive. The photograph includes Lewis Mekeel, his wife Elizabeth Hunter Mekeel, Charity Pringle Mekeel, Coral Mekeel Nesbitt, and Hattie Mekeel Ide. In the wagon are Thomas Mekeel, Rebecca Meeker Mekeel, Ethel Mekeel, and Gertrude Mekeel, with Lewis Mekeel Jr. on the horse and Jack Lee by the fence. (Courtesy of Judith Simms Dawe.)

FARM PURCHASED IN 1847 BY WILLIAM HENRY MAJOR. The William Henry Major farm was later owned and operated by his descendants William Dawe and Christopher Dawe. In 1829, a petition was signed by 32 residents to create Lehman Township, named in memory of Dr. William Lehman of Philadelphia (1779–1829). The petition was signed by members of the Ide, Honeywell, Spencer, and Shaver families. (Courtesy of Judith Simms Dawe.)

MOUNTAIN VIEW DRIVE LOOKING TOWARD LEHMAN CENTER, 1900S. Formerly part of the certified Bedford Township, Lehman became the 10th township in Luzerne County. Lehman was known for its lumber and farming in the 1800s. In the 1830s and 1840s, several mills were built in Lehman and operated by R. W. Foster, J. Harris, Frederick Hartman, Ansel Hoyt, Lewis Hoyt, and George Sorber. (Courtesy of Judith Simms Dawe.)

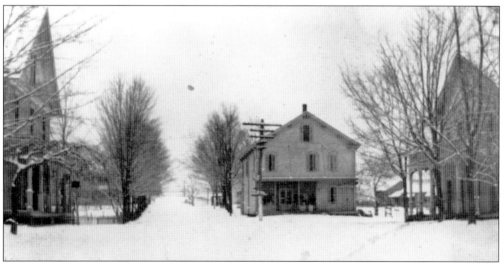

LEHMAN CENTER, C. WINTER 1900. This photograph of Lehman Center shows a large set of scales for weighing freight in the center. This photograph shows the store owned by Thomas Nelson Major on the left, the William Neely store in the middle, and the Gleason House on the right. William Neely had traded businesses with William C. Johnson before 1900, and William Neely bought the store in Lehman. (Courtesy of the FCP collection.)

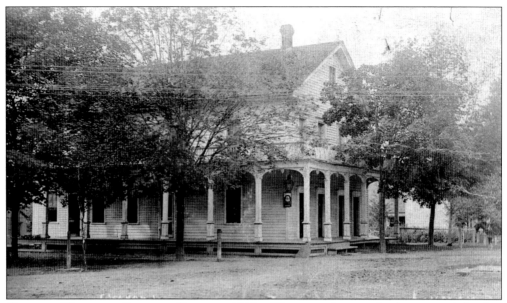

GLEASON HOUSE AT LEHMAN CENTER, 1900S. This was close to the location of the first general store operated by Daniel Urquhart and Edward Shott in 1848. Note the Stegmaier Beer advertisement on the front porch. In 1857, the Baer and Stegmaier Brewery opened on South Canal Street in Wilkes-Barre. The brewery was a partnership between Charles Stegmaier and his father-in-law George Baer. (Courtesy of Judith Simms Dawe.)

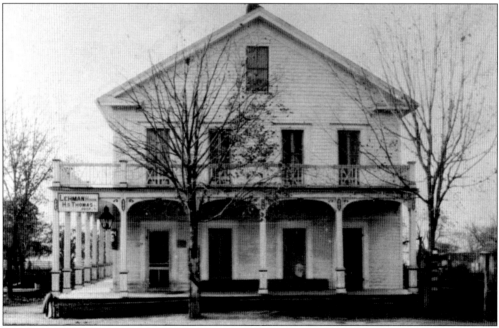

LEHMAN HOUSE FROM LEHMAN CENTER, 1905. The Gleason House became the Lehman House, and the restaurant and boardinghouse were operated by H. S. Thomas. The restaurant was known for its Sunday chicken dinners. The Women's Christian Temperance Union, founded by Frances Willard (1839–1898), stopped the sale of alcohol at the Lehman House. The building was destroyed by fire in 1918. (Courtesy of Judith Simms Dawe.)

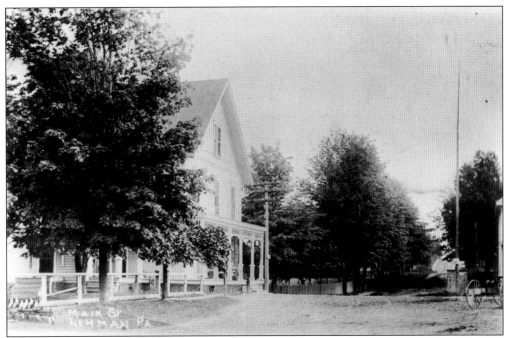

STORE OWNED BY THOMAS NELSON MAJOR, 1890s. This postcard shows the store at Lehman Center looking toward Mountain View Drive. The building was constructed in the 1870s, and the third story was added to the store after 1890. In the early 1900s, the store served as the Lehman Post Office. It was later razed, and a house was built by the Major family on the same location. (Courtesy of Judith Simms Dawe.)

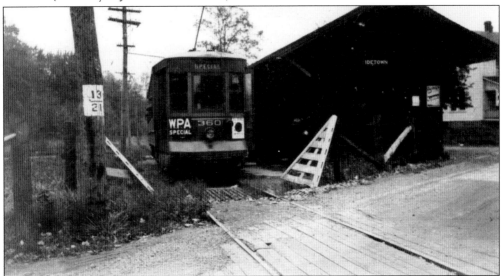

WILKES-BARRE RAILWAY CORPORATION TROLLEY NO. 360 AT THE IDETOWN STATION, 1936. Idetown was named for Nehemiah Ide (1746–1823). After regular trolley service to Harvey's Lake was discontinued on September 16, 1931, special excursions like this one for Works Progress Administration workers operated to the Idetown station. Leaning against the station is a cowcatcher or pilot used to move livestock off the trolley tracks. (Courtesy of the Edward S. Miller collection.)

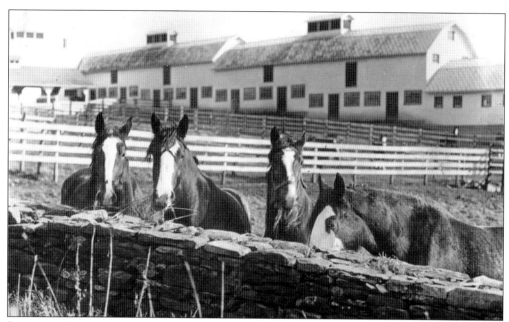

JENNINGS STUDIO PHOTOGRAPH OF THOROUGHBRED HORSES IN FRONT OF THE BARNS AT HAYFIELD FARM, 1930S. In 1910, Hayfield Farm was founded by John N. Conyngham II, son of William L. Conyngham. He purchased the property from Robert Major, George Major, and David Major on Old Route 115 in Lehman. Golden Knight was one of the award-winning Clydesdales raised at Hayfield Farm. (Courtesy of John N. Conyngham III.)

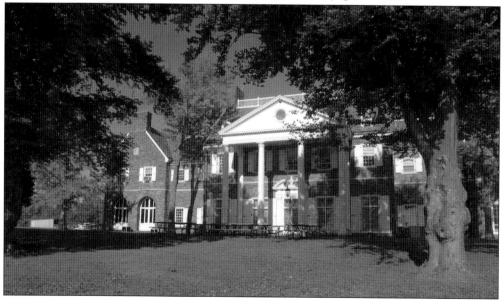

HAYFIELD HOUSE. In 1932, the Hayfield House was designed by architect Francis Nelson and constructed by Skinner, Cook and Babcock. In 1933, John N. Conyngham II and his wife Bertha Robinson Conyngham moved into the house. After the death of Bertha Robinson Conyngham in 1964, Hayfield House was donated to Pennsylvania State University and converted into offices and classrooms for Pennsylvania State University Wilkes-Barre. (Courtesy of Mark Gregario and Pennsylvania State University.)

Four

HARVEY'S LAKE

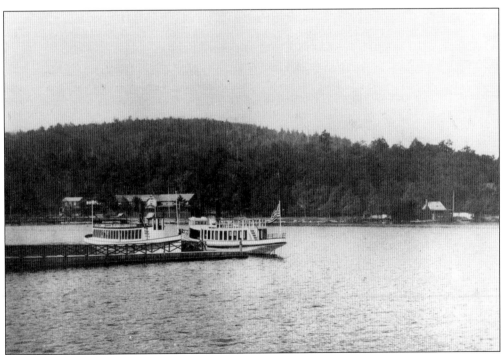

STEAMBOATS ROSALIND AND BIG BOAT ON HARVEY'S LAKE. These boats are seen at the Rhoads Hotel landing in 1893, with the inlet iron bridge and the Lake Grove House in the background. The *Big Boat* was launched in 1891 and was owned by William Bond, who renamed it the *A. H. Lewis*. In 1895, the Lake Transit Company purchased the steamboat for $3,500 and renamed it the *Shawanese*. It was in service until 1909. (Courtesy of the Luzerne County Historical Society.)

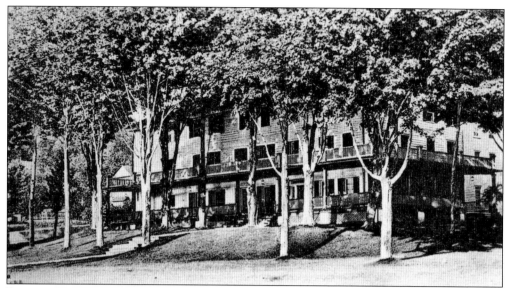

RHOADS HOTEL, 1900S. This view was taken from the Rhoads Hotel landing on Harvey's Lake. Originally called the Lake House, it was the earliest hotel on the lake and catered to the tourist trade. Construction began in 1854, and the Lake House opened in July 1855. In 1873, the hotel was purchased by Washington Lee, and he hired James W. Rhoads to manage the Lake House. (Courtesy of Louise Schooley Hazeltine.)

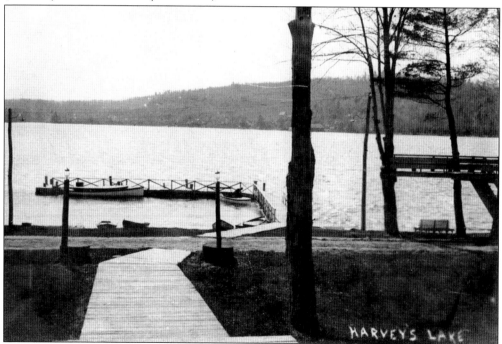

RHOADS HOTEL LANDING AND BOARDWALK, 1900. In March 1875, James W. Rhoads purchased the hotel for $8,500. He renamed it the Harvey's Lake Hotel, but it was called the Rhoads Hotel. James W. Rhoads made many improvements to the hotel, including running water, bathtubs, and kerosene lamps. In 1881, daily rates were $2.25. (Courtesy of the Luzerne County Historical Society.)

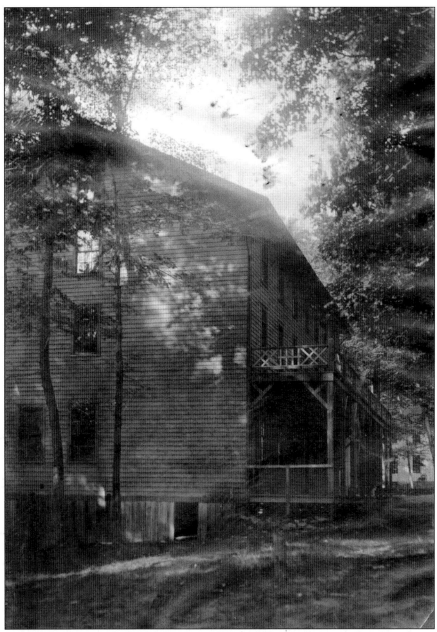

RHOADS HOTEL AT THE HEIGHT OF POPULARITY, 1904. The three-story hotel accommodated 100 guests and was located near the intersection of Carpenter Road and Lakeside Drive. Guests arrived by stagecoach, train, steamboat, and trolley. After James W. Rhoads passed away in 1886, the hotel was managed by his widow, Caroline E. Rhoads, until her death two years later. Their sons Charles and Frank Rhoads operated the hotel until 1908. The steamboat *Natoma* often catered to guests at the Rhoads Hotel and took passengers to other attractions around Harvey's Lake. In September 1900, the hotel hosted a reunion for Civil War veterans of the 143rd Pennsylvania Volunteer Infantry Regiment. A fire caused by a defective furnace pipe burned the Rhoads Hotel to the ground on January 4, 1908. (Courtesy of the Misericordia University Archives.)

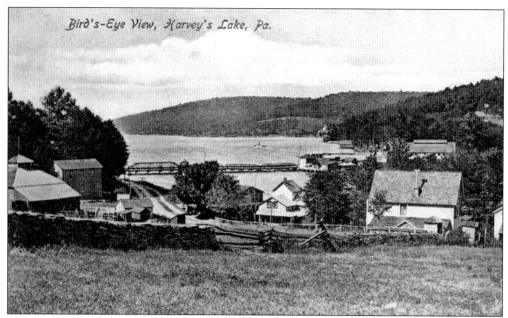

LAKESIDE ATTRACTIONS AT HARVEY'S LAKE, 1900s. This postcard shows the inlet iron bridge, Hill's pavilion, the bathing houses, and other lakeside attractions on the right. The inlet filled in over time, and the modern concrete bridge on Lakeside Drive was built close to the original location of the inlet iron bridge. This photograph shows a steamboat in the background leaving the Rhoads Hotel landing for the picnic grounds. (Courtesy of Louise Schooley Hazeltine.)

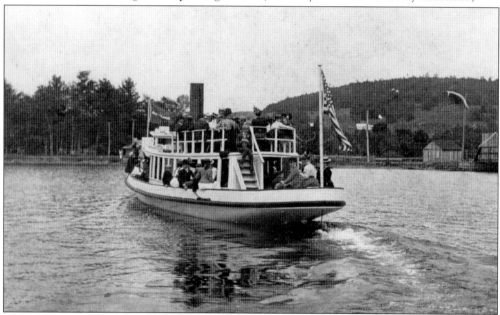

ROSALIND TRANSPORTS PASSENGERS TO THE LEHIGH VALLEY RAILROAD PICNIC GROUNDS. The steamboat *Rosalind* was built by William R. Osborn for the Lake Transit Company and launched on May 9, 1893. The *Rosalind* was 60 feet long and 14 feet wide. In 1905, it was sold and taken by train to Lake Carey, where it sank due to ice damage in the winter of 1911–1912. (Courtesy of the Luzerne County Historical Society.)

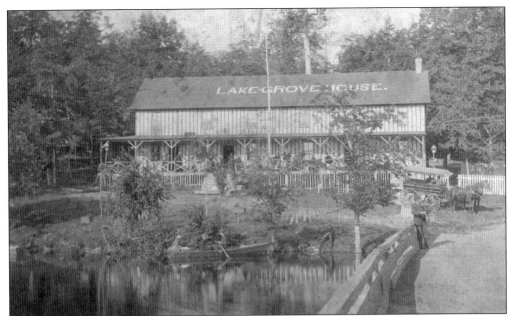

LAKE GROVE HOUSE SEEN FROM THE INLET WOODEN BRIDGE, 1880S. The Lake Grove House was built by Jacob Rice in 1881. A veteran of the Civil War, Jacob Rice served in the 53rd Pennsylvania Infantry Volunteer Regiment. As Harvey's Lake grew in popularity, the hotel was frequented by many guests. One Sunday afternoon in July 1882, over 300 guests visited the hotel. (Courtesy of the Luzerne County Historical Society.)

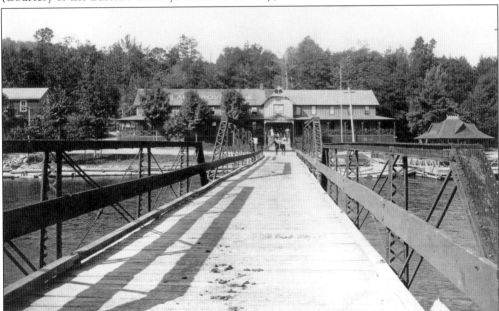

LAKE GROVE HOUSE FROM THE INLET IRON BRIDGE, 1893. This view was taken after the bridge was completed. The hotel was purchased by Samuel Gottfried in 1891, and he built a new addition in April 1892. The Lake Grove House was sold to the Harvey's Lake Hotel and Land Company in 1897, and the property was used to build the Oneonta Hotel. (Courtesy of the Luzerne County Historical Society.)

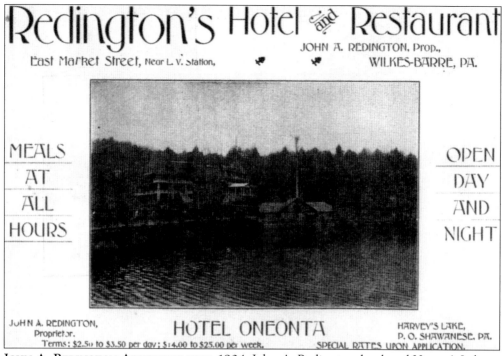

JOHN A. REDINGTON ADVERTISEMENT, 1904. John A. Redington developed Harvey's Lake as a resort by utilizing transportation to bring tourists to lakeside attractions. The Oneonta Hotel was a modern four-story hotel with electricity, running water, and steam heat. The hotel opened on April 14, 1898. It was owned by the Harvey's Lake Hotel and Land Company. (Courtesy of Howard and Lillian Gola.)

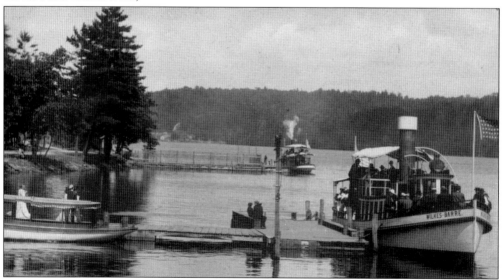

THE WILKES-BARRE AT THE ONEONTA HOTEL LANDING, 1905. William R. Osborn built the steamboat *Wilkes-Barre* for the Harvey's Lake Steamboat Company. The *Wilkes-Barre* was launched in 1903 and was 70 feet long and 12 feet wide. The *Acoma* (seen in the background) was built by William R. Osborn for the Lake Transit Company. It was launched on June 29, 1905, and was 75 feet long and 16 feet wide. (Courtesy of the FCP collection.)

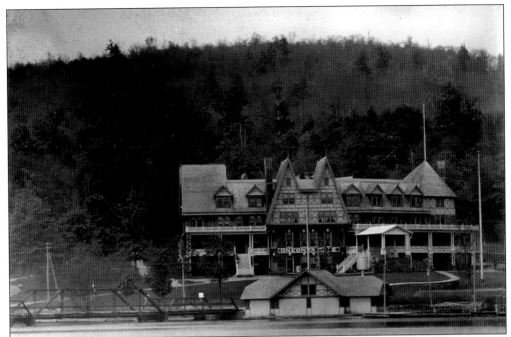

ONEONTA HOTEL SEEN FROM A STEAMBOAT, 1906. Guests reached the hotel by steamboat, from the Alderson train station and the trolley station located on Oneonta Hill behind the hotel. John A. Redington leased the picnic grounds from the Lehigh Valley Railroad in 1906, and he capitalized on the steamboat traffic around Harvey's Lake. (Courtesy of the Luzerne County Historical Society.)

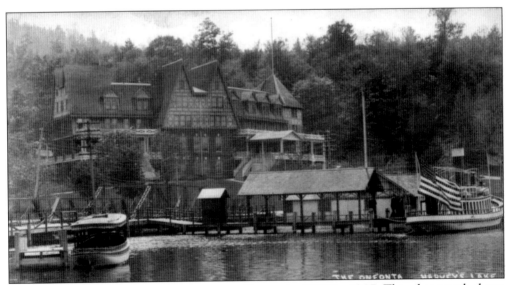

WILLIAM J. HARRIS PHOTOGRAPH OF THE ONEONTA HOTEL, 1907. This photograph shows the Harvey's Lake Steamboat Company landing for the steamboats *Kingston* and *Wilkes-Barre*, with the *Wilkes-Barre* ready to depart for the Lehigh Valley Railroad picnic grounds. The smaller boat on the left was used by the Oneonta Hotel to transport passengers when the steamboats were unavailable. (Courtesy of the Misericordia University Archives.)

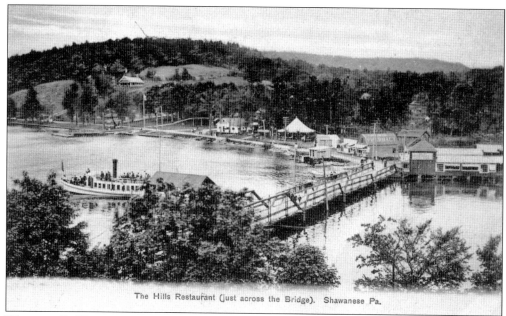

WILLIAM J. HARRIS POSTCARD OF STEAMBOAT LEAVING THE INLET, C. 1905. In the background is the landing at the Rhoads Hotel and a carousel under a canopy on the lakefront. Hill's pavilion was located at the end of the inlet iron bridge on the right. The attractions at Harvey's Lake were once called "Little Coney." (Courtesy of Howard and Lillian Gola.)

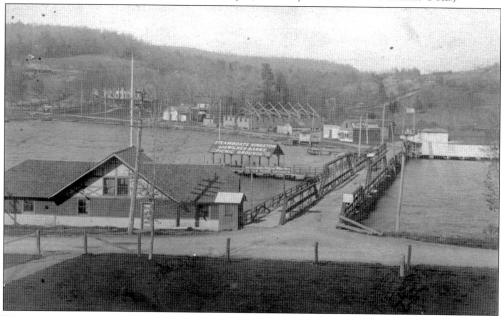

VIEW OF THE LAWN IN FRONT OF THE ONEONTA HOTEL, C. 1905. This view shows the lawn overlooking the inlet iron bridge on Harvey's Lake and the landing for the steamboats owned by the Harvey's Lake Steamboat Company. The competing steamboat companies consolidated in 1909, and the assets of the Harvey's Lake Steamboat Company were purchased by the Lake Transit Company. Steamboat traffic declined by the 1920s. (Courtesy of the Luzerne County Historical Society.)

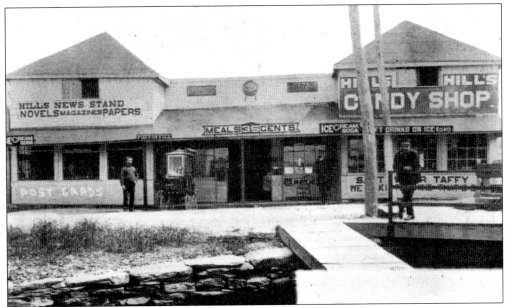

HILL'S PAVILION, 1904. Hill's pavilion was located at the end of the inlet iron bridge near the present location of Grotto's Pizza. It was run by William and Martha Hill, and it offered a restaurant, store, and souvenir shop that sold postcards and saltwater taffy. Hill's pavilion was built by Thomas Major. It was sold to J. Lynn Johnson in 1917. (Courtesy of Howard and Lillian Gola.)

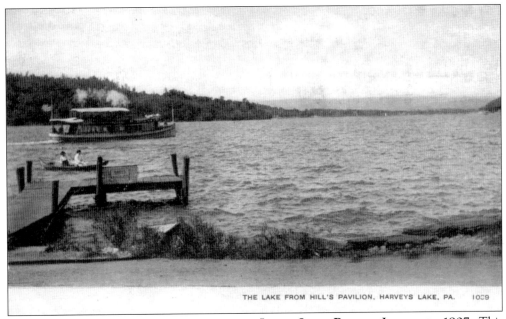

THE WILKES-BARRE DEPARTING FROM THE INLET IRON BRIDGE LANDING, 1907. This photograph was taken by William J. Harris near the dock in front of the Hill's pavilion at Harvey's Lake. The Lake Transit Company general manager was Clarence Shaver. In June 1909, the company acquired the *Wilkes-Barre* and *Kingston*. The steamboats had awnings to protect passengers from the summer sun. (Courtesy of Howard and Lillian Gola.)

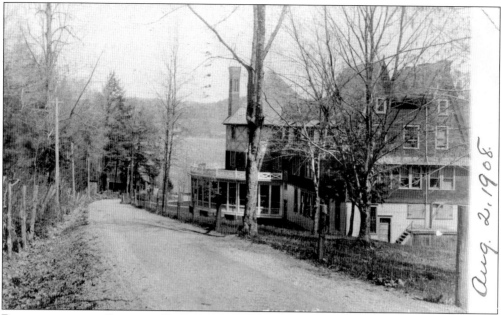

ROAD BEHIND THE ONEONTA HOTEL, 1908. This road led to the Harvey's Lake trolley station on Oneonta Hill. The Oneonta Hotel and the trolley station opened in 1898. The hotel was built by Wilkes-Barre contractor P. R. Raife, and it offered 70 rooms, some with private baths. The hotel owners and the trolley company wanted to develop Harvey's Lake into a resort destination. (Courtesy of the Luzerne County Historical Society.)

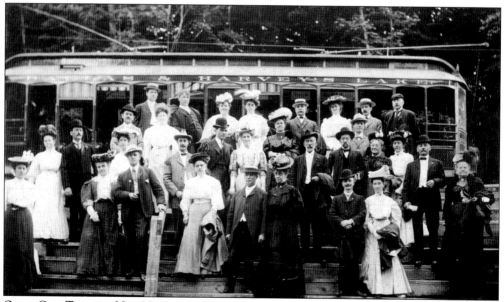

OPEN-CAR TROLLEY NO. 89 AT THE HARVEY'S LAKE STATION ON ONEONTA HILL. In 1897, the 10-bench trolley No. 89 was built by Jackson and Sharp in Wilmington, Delaware. Open-car trolleys operated from the public square in Wilkes-Barre to Harvey's Lake during the summer months. The Harvey's Lake station was abandoned after trolley service between Dallas and Harvey's Lake was replaced by bus service on September 16, 1931. (Courtesy of Dominic P. Fino Sr.)

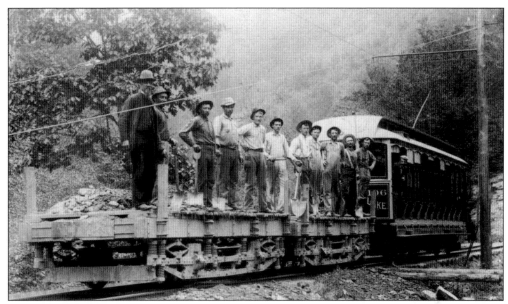

FOREMAN EDWARD BAER AND WORKMEN, C. 1897–1898. The men are pictured on a flatbed and trolley No. 106 near the Harvey's Lake trolley station. The trolley line was built by the Wilkes-Barre, Dallas and Harvey's Lake Railway Company to attract tourists to Harvey's Lake. Several stockholders in the company incorporated the Harvey's Lake Hotel and Land Company to construct the Oneonta Hotel on April 20, 1897. (Courtesy of the Misericordia University Archives.)

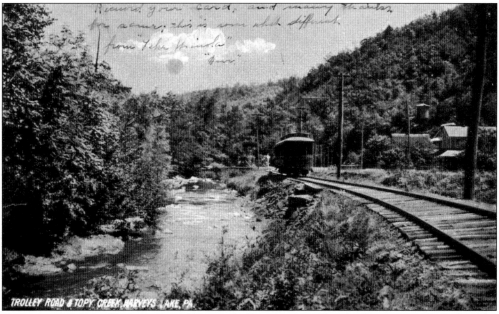

TROLLEY BETWEEN DALLAS AND HARVEY'S LAKE NEAR TOBY'S CREEK, 1907. Before the days of automobiles, the trolley and the Lehigh Valley Railroad brought passengers to Harvey's Lake. Travelers came from New York and Philadelphia to enjoy the lakeside attractions. This photograph was taken by William J. Harris, and the postcard was sold at the Hill's pavilion on the inlet iron bridge. (Courtesy of Howard and Lillian Gola.)

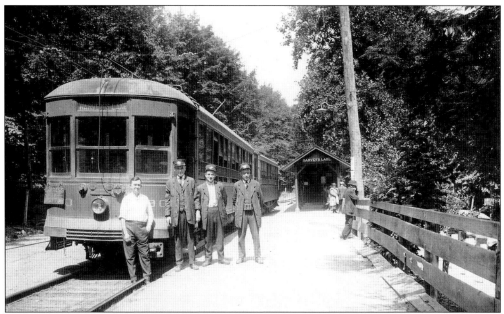

EXPRESS TROLLEY NO. 380 AT THE TROLLEY STATION, 1920S. This photograph includes, from left to right, trolley operators Mr. Keithline, Charles Reid, and Johnson Van Buren Coolbaugh. It shows two trolleys connected by Tomlinson couplers forming a doubleheader to accommodate more passengers. Doubleheaders were prone to accidents. Both trolleys were delivered to the Wilkes-Barre Railway Corporation in 1913. (Courtesy of Joan Coolbaugh Britt.)

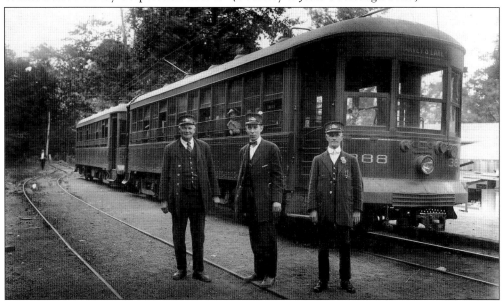

DOUBLEHEADER LED BY TROLLEY NO. 388, 1920S. This Wilkes-Barre Railway Corporation trolley is pictured near the passing track at the Harvey's Lake trolley station. The trolley station was close to the Hill's refreshment stand on Oneonta Hill. This photograph includes, from left to right, trolley operators Jim Evans, Jonah Woods, and Mr. Metzger. Due to financial restraints and increased automobile traffic, trolley service to Harvey's Lake was discontinued in 1931. (Courtesy of Joan Coolbaugh Britt.)

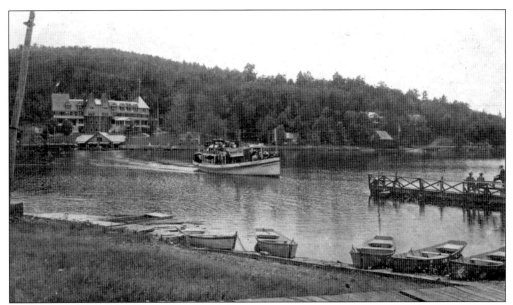

ONEONTA HOTEL SEEN FROM LAKESIDE DRIVE, C. 1908. A steamboat can be seen arriving at the Rhoads Hotel landing in the background. Although in competition with other hotels on the lake, the Oneonta Hotel was the last 19th-century hotel built specifically to cater to tourists coming to Harvey's Lake after the development of the Lehigh Valley Railroad and the trolley line. (Courtesy of the Luzerne County Historical Society.)

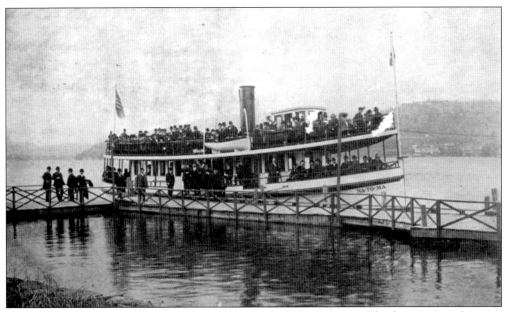

THE NATOMA AT THE RHOADS HOTEL LANDING, JULY 4, 1910. The largest steamboat on Harvey's Lake, the *Natoma* was launched by the Lake Transit Company near the Oneonta Hotel on June 9, 1900. It cost $3,000 to build and could accommodate 350 passengers. It was the only steamboat on Harvey's Lake with a full upper deck and was in service until 1938. (Courtesy of the Luzerne County Historical Society.)

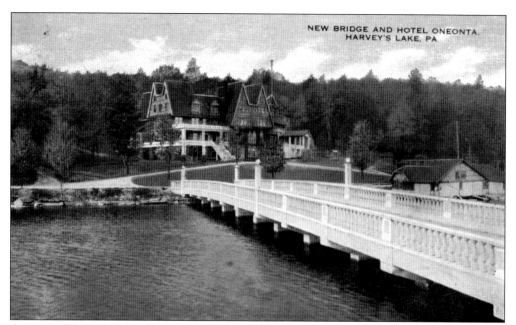

ONEONTA HOTEL, 1916. This view was taken near the 315-foot concrete inlet bridge that opened in 1914. It became the premier hotel at Harvey's Lake. Former president Theodore Roosevelt visited the Oneonta Hotel on August 22, 1912. The hotel was destroyed by a mysterious fire on February 2, 1919. The Oneonta pavilion was built on the property, and it opened on May 27, 1922. (Courtesy of Howard and Lillian Gola.)

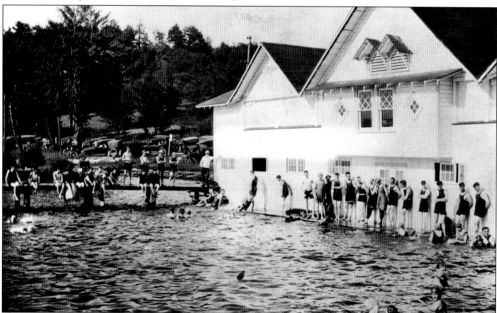

SUNSET DANCE PAVILION, 1925. The Sunset Dance Pavilion opened at Harvey's Lake in 1920, and it was owned by L. C. Schwab. In 1926, the pavilion was managed by J. B. Reilly, and it was in direct competition with the Oneonta pavilion. Many big band leaders performed in the dance halls at Harvey's Lake. This photograph was taken after swimming docks were added to the pavilion. (Courtesy of the Luzerne County Historical Society.)

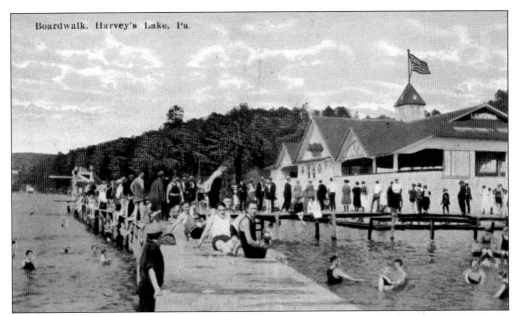

SWIMMING DOCK, 1920s. This William J. Harris view of the swimming dock at Harvey's Lake shows the Sunset Dance Pavilion in the background. The Lake Improvement Company was created by George W. Bennethum to purchase and develop the lakefront in 1922. Swimming was popular, and bathhouses on the boardwalk rented towels and bathing suits. In 1929, the Sunset Dance Pavilion was destroyed by fire. (Courtesy of Howard and Lillian Gola.)

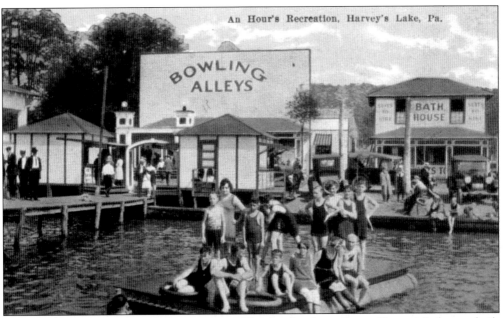

SUNSET BEACH AT HARVEY'S LAKE, 1920s. The first bowling alley at Harvey's Lake was built by John B. Reynolds, Clinton Honeywell, and A. A. Holbrook near the Rhoads Hotel in 1905. This postcard shows the boardwalk and swimming docks near the inlet bridge. Many lakeside attractions were destroyed by two fires, in 1928 and 1929. The modern concrete bridge was constructed in 1928. (Courtesy of Howard and Lillian Gola.)

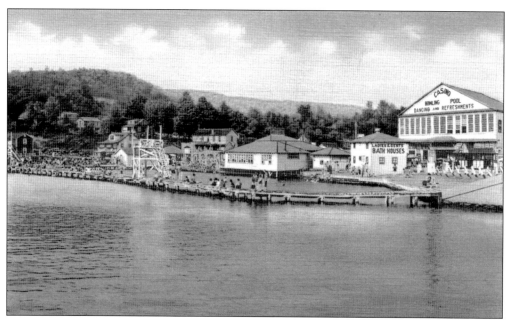

HARVEY'S LAKE, C. 1925. Frank Devlin of Wilkes-Barre purchased lakefront lots near the inlet bridge and the swimming docks. He developed the property and built the casino that opened on Memorial Day in 1924. It featured dining facilities for 250 people, a gift shop, a grocery store, a dance hall, and the largest bowling alley in northeastern Pennsylvania. The casino was demolished in 1980. (Courtesy of Howard and Lillian Gola.)

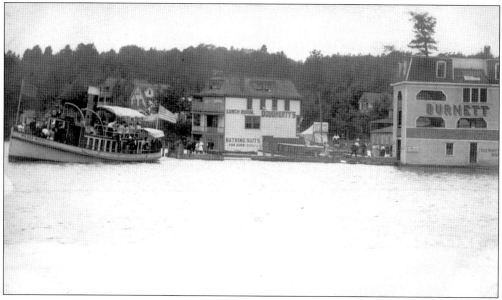

THE *WILKES-BARRE* DEPARTS THE RESTAURANT LANDING. The landing was owned by Charles Lord close to the picnic grounds in about 1908. The picnic grounds were created by the Lehigh Valley Railroad for its employees in 1891 and quickly gained popularity as a tourist attraction. This photograph shows the lakefront bathhouse and restaurant owned by George Burnett and an ice-cream parlor run by Michael Dougherty. (Courtesy of the Luzerne County Historical Society.)

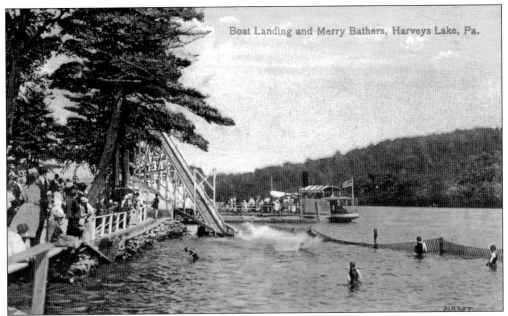

SHOOT-THE-CHUTE, 1915. The 60-foot-high Shoot-the-Chute can be seen with the steamboat *Acoma* at the Lehigh Valley Railroad picnic grounds landing. The Shoot-the-Chute was built by Charles Shelley in 1910, and it was one of the largest attractions at Harvey's Lake. The steamboats transported passengers from the train station and the hotels to the picnic grounds and to other lakeside attractions. (Courtesy of the Luzerne County Historical Society.)

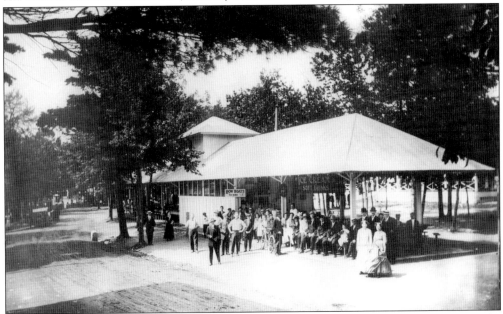

OPEN PAVILION, 1915. The open pavilion at the picnic grounds was across the road from the Shoot-the-Chute. In 1916, the Lehigh Valley Railroad renewed its lease of the picnic grounds to John A. Redington, who planned to develop the property into an amusement park. The open pavilion was replaced with a restaurant built by George H. Jenkins and owned by Alfred Wintersteen in 1921. (Courtesy of the Luzerne County Historical Society.)

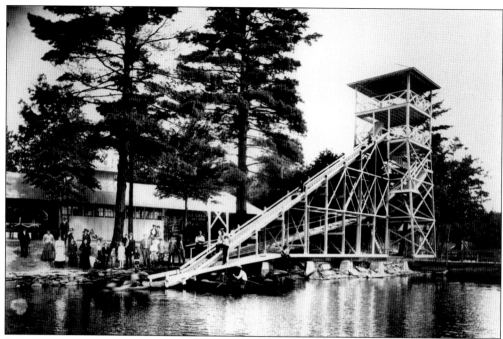

SHOOT-THE-CHUTE WITH THE OPEN PAVILION IN THE BACKGROUND, C. 1920. In 1922, John A. Redington, Alfred Wintersteen, Charles Lee, and George Heller formed the Harvey's Lake Park Company to manage the park. The company developed the park, constructed a dance pavilion, and several new rides were built, including the Speed Hound roller coaster. (Courtesy of the Curt Teich Postcard Collection, Lake County Museum.)

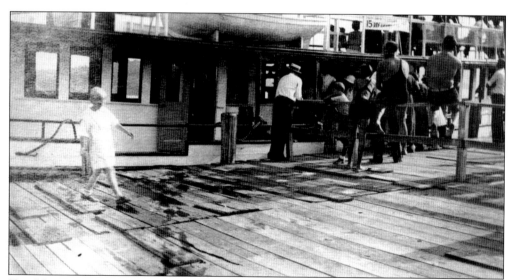

THE NATOMA, C. 1915. The year 1919 was a busy season for the steamboats, carrying 15,876 passengers on July 4 at 15¢ a ticket. In 1932, the assets of the Lake Transit Company were sold for $4,000, and the *Natoma* was purchased by Oscar Roth and Robert Roberts. The *Natoma* was the last steamboat on Harvey's Lake; it made its final voyage in the summer of 1938. (Courtesy of Pauline Shaver Roth.)

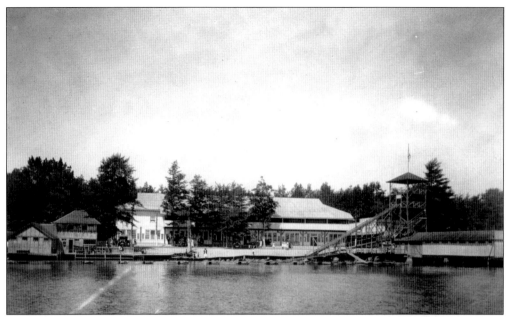

DANCE PAVILION AND RESTAURANT AT HARVEY'S LAKE PARK. In 1930, the park was sold to Nettie Wintersteen and John E. Hanson. Following the death of her husband, Alfred Wintersteen, Nettie Wintersteen sold her half-interest in the park to John E. Hanson. When Hanson's Amusement Park opened in 1935, the Wintersteen family leased the carousel and the Dodgem ride to the amusement park. (Courtesy of the FCP collection.)

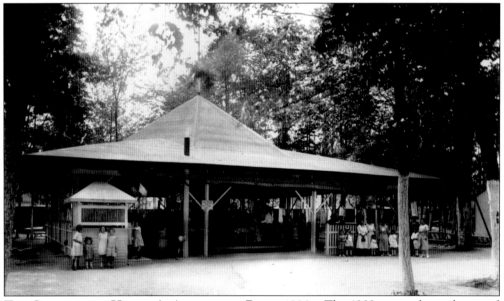

THE CAROUSEL AT HANSON'S AMUSEMENT PARK, 1930S. The 1909 carousel was decorated with hand-carved animals by Charles Looff, Solomon Stein, Harry Goldstein, and Charles Carmel. In 1914–1915, the Wintersteen family purchased it from the W. F. Mangels Carousel Works of Coney Island. The carousel was a landmark at Harvey's Lake until the park closed in 1984. It was leased in Kissimmee, Florida, and was moved to Auburndale, Florida. (Courtesy of the FCP collection.)

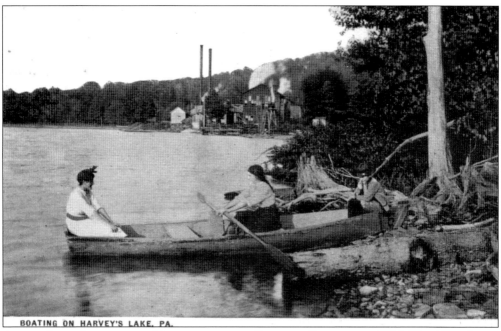

BOATING ON HARVEY'S LAKE, PA.

ALBERT LEWIS LUMBER AND MANUFACTURING COMPANY SAWMILL, C. 1910. The Albert Lewis Lumber and Manufacturing Company was incorporated in 1890. Albert Lewis was instrumental in developing the Bowman's Creek branch of the Lehigh Valley Railroad. He purchased over 13,000 acres along Bowman's Creek and opened the area to the lumber industry. The sawmill closed in 1914, and it was dismantled in 1917–1918. (Courtesy of Howard and Lillian Gola.)

LEHIGH VALLEY RAILROAD SCHEDULE, 1892. The trains ran from Wilkes-Barre to Harvey's Lake and Noxen. At this time, the Lehigh Valley Railroad was a division of the Reading Railroad system. The railroad offered freight service for Back Mountain businesses. The final stop on the schedule was the Noxen station. The North Branch Land Trust restored the Noxen station, the only surviving train station in the Back Mountain. (Courtesy of Howard and Lillian Gola.)

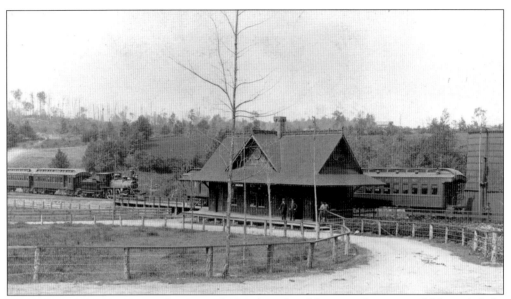

ALDERSON STATION, 1892. The original 12-mile railroad between Luzerne and Harvey's Lake was sold to the Lehigh Valley Railroad by Albert Lewis on August 5, 1887. Regular passenger train service between Wilkes-Barre and Harvey's Lake started on November 23, 1891. In 1888, the Alderson Methodist Episcopal Church was constructed on Harvey's Lake. The Alderson station and the Lehigh Valley Railroad picnic grounds were constructed in 1891. (Courtesy of the FCP collection.)

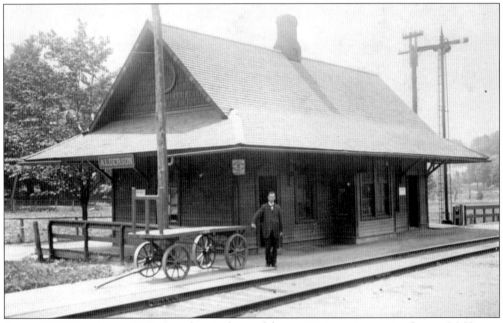

ALDERSON STATION, C. 1910. Standing in front of the station is stationmaster George M. Young. The Alderson station was utilized by the Albert Lewis Lumber and Manufacturing Company sawmill, the ice-cutting industry, and the Mosser tannery in Noxen. In 1891, the Lehigh Valley Railroad built a direct line between Wilkes-Barre and Harvey's Lake. The Alderson station was dismantled in 1958. (Courtesy of the Misericordia University Archives.)

LEHIGH VALLEY RAILROAD CARS, 1940S. Pictured here are an engine, coal car, and caboose on Harvey's Lake after passing under the Speed Hound roller coaster at Hanson's Amusement Park. The last advertised passenger train to Harvey's Lake was in 1936. The Mosser tannery in Noxen was in operation until 1961. The Lehigh Valley Railroad abandoned the Bowman's Creek branch in the Back Mountain on December 22, 1963. (Courtesy of the Misericordia University Archives.)

SEAPLANE ACCIDENT ON HARVEY'S LAKE, SEPTEMBER 1941. Ted Frantz Jr., who built Stonehurst Lodge at Harvey's Lake, drowned when his motorboat struck this seaplane moored on the lake near the Girl Scout camp in September 1941. The seaplane was owned by Mack A. Stogner, who was visiting from New York City. In 1947, Russell Smith opened the Smith Flying Service on Harvey's Lake and offered flying lessons and charter flights. (Courtesy of the Harvey's Lake Yacht Club.)

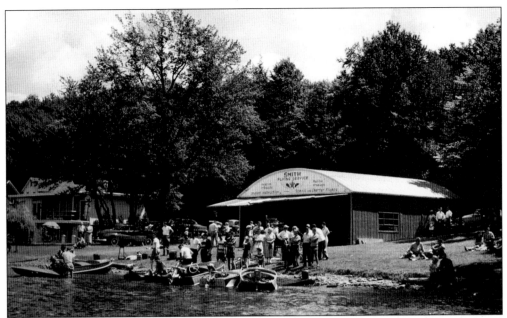

SMITH FLYING SERVICE HANGAR, JULY 8, 1951. The Harvey's Lake Boat Club purchased lakefront property next to the hangar on September 12, 1950. The club held meetings in the hangar and purchased the property from Russell Smith in 1962. The Harvey's Lake Boat Club passed a resolution on July 6, 1963, and became the Harvey's Lake Yacht Club. (Courtesy of the Harvey's Lake Yacht Club.)

HARVEY'S LAKE BOAT CLUB MOTORBOAT RACE, 1951. The Harvey's Lake Boat Club was incorporated in 1940–1941 when annual dues were $5. Many early members owned motorboats, including Chris Craft. Motorboats were popular on the lake, and several races were sponsored by the American Power Boat Association. The last motorboat race took place on Harvey's Lake in 1959. (Courtesy of the Harvey's Lake Yacht Club.)

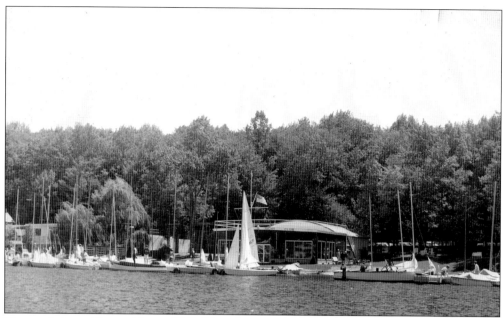

HARVEY'S LAKE YACHT CLUB, 1967. This photograph was taken after a sailboat race on Labor Day. The club chartered the Comet sailboat fleet in 1959. Sailboat races were frequently held by the Harvey's Lake Yacht Club with the Comet and Mobjack sailboat fleets. The hangar was renovated and was used as the club's headquarters, and the dock was built in front of the property. (Courtesy of the Harvey's Lake Yacht Club.)

MOBJACK SAILBOAT RACE, 1984. The sailboat in this photograph was owned by John Bourke. In the background is the 65-foot-high Speed Hound roller coaster built in 1931 by John A. Miller and Oscar E. Bittler for $10,825 at Hanson's Amusement Park. The roller coaster closed down in 1980. When the park closed in 1984, the contents were auctioned on September 26, 1984. (Courtesy of the Harvey's Lake Yacht Club.)

Bibliography

Brewster, William. *History of the Certified Township of Kingston, Pennsylvania, 1769–1929.* Wilkes-Barre, PA: Smith-Bennett Corporation, 1929.

Cox, Harold E. *Wyoming Valley Trolleys: Street Railways of Wilkes-Barre, Nanticoke and Pittston, Pennsylvania.* Forty Fort, PA: Self-published, 1988.

Greenberg, William T., Frederick A. Kramer, and Theodore F. Gleichmann Jr. *The Handsomest Trains in the World: Passenger Service on the Lehigh Valley Railroad.* New York: Quadrant Press, 1978.

Hazeltine, Ralph L. *A Brief History of George M. Dallas Lodge, No. 531, F. & A. M.: Dallas, Luzerne County, Pennsylvania.* 1950.

———. *History of the Township of Kingston 1769–1976: Early Settlement of the Fourth Division.* Kingston, PA: Bicentennial Commission, 1976.

Kelly, Dr. Regina Kelly, RSM, and Dr. Agnes Toloczko Cardoni. *At the Edge of Centuries: College Misericordia, 1913–1999.* Dallas, PA: College Misericordia Press, 1999.

Owens, Harry D. Jr. "The Bowman's Creek Branch of the Lehigh Valley Railroad." *Flags, Diamonds, and Statues* 13 No. 1 (1996): 5–21.

Petrillo, F. Charles. *Harvey's Lake.* Wilkes-Barre, PA: Bookmakers, 1991.

Ryman, William Penn. "The Early Settlement of Dallas Township, Pennsylvania." In Vol. VI, *Proceedings and Collections of the Wyoming Historical and Geological Society,* 142–288.

Rohrbeck, Benson W. *Wilkes-Barre Railways Company.* Pennsylvania Traction Series. West Chester, PA: 1978.

Schooley, Dr. Frank Budd. *The Word.* Dallas, PA: Payne Printery, 1967.

Waters, Daniel A. *Dallas Pennsylvania History: Township Sesquicentennial 1817–1967 and Prior History.* Dallas, PA: 1967.

Whipkey, Harry E. *After Agnes: A Report on Flood Recovery Assistance by the Pennsylvania Historical and Museum Commission.* Harrisburg, PA: Pennsylvania Historical and Museum Commission, 1973.

Zbiek, Dr. Paul J. *Luzerne County: History of the People and Culture.* Lancaster, PA: Wyoming Historical and Geological Society and Strategic Publications, 1994.

Across America, People are Discovering Something Wonderful. Their Heritage.

Arcadia Publishing is the leading local history publisher in the United States. With more than 3,000 titles in print and hundreds of new titles released every year, Arcadia has extensive specialized experience chronicling the history of communities and celebrating America's hidden stories, bringing to life the people, places, and events from the past. To discover the history of other communities across the nation, please visit:

www.arcadiapublishing.com

Customized search tools allow you to find regional history books about the town where you grew up, the cities where your friends and family live, the town where your parents met, or even that retirement spot you've been dreaming about.